The MARBLE CITY

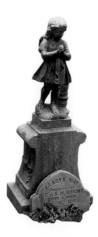

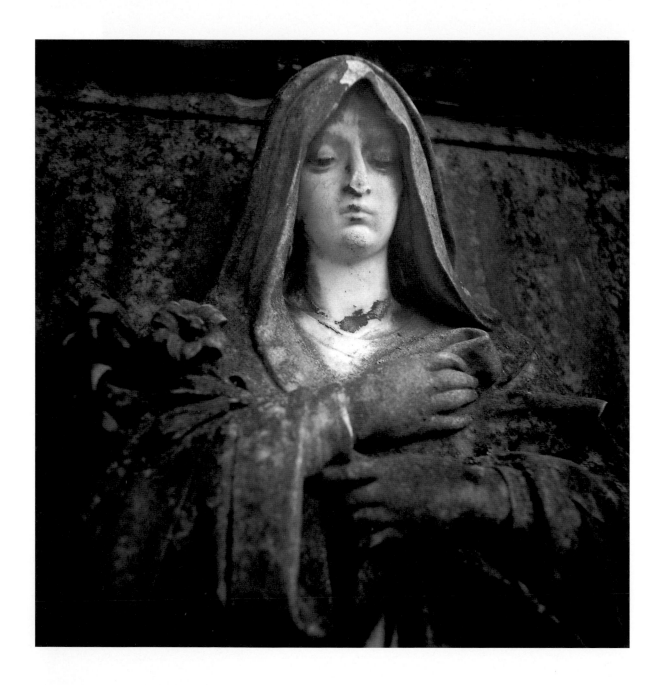

THE · MARBLE · CITY

A PHOTOGRAPHIC TOUR *of* KNOXVILLE'S GRAVEYARDS

Text by

JACK NEELY

Photographs by

AARON JAY

With a Foreword by

CHRISTINE PATTERSON

The University of Tennessee Press / Knoxville

Library of Congress Cataloging-in-Publication Data

Neely, Jack.
 The marble city : a photographic tour of Knoxville's graveyards / text by Jack Neely ; photographs by Aaron Jay ; with a foreword by Christine Patterson. — 1st ed.
 p. cm.
Includes bibliographical references (p.).
isbn 1-57233-043-0 (cl.: alk. paper)
isbn 1-57233-036-8 (pbk.: alk. paper)
1. Knoxville (Tenn.)—Pictorial works. 2. Knoxville (Tenn.)—Tours. 3. Cemeteries—Tennessee—Knoxville—Pictorial works. I. Jay, Aaron, 1971– II. Title.
F444.K7 N44 1999
976.8'85'00222—ddc21
 98-40116

To Janet, Sam, and Rebecca

for their patience with an obsessive

—J. N.

To my sweet Ali

—A. J.

CONTENTS

ILLUSTRATIONS

FOREWORD

I must admit at the outset that I was a little embarrassed at how little I knew about my community and hometown of Knoxville, even though I have had the privilege of traveling the length and breadth of Tennessee chronicling the history of this wonderful state in a book of photographs. After reading *The Marble City,* written so eloquently by Jack Neely and skillfully photographed by Aaron Jay, it was as though Jack and Aaron had pulled up an old rocker for me as they began to relate a story of Knoxville's history as told through its cemeteries.

Buried in our Knoxville soil are layers of precious history—history that some have carefully remembered but others have long forgotten. But as the soil remains fertile for growth, so do the memories and history-making events that are encapsulated in Knoxville's graveyards.

The Marble City's two artists—one literary and the other photographic—have cast a backward glance that initially leads the reader to the gravesite, and then through words captivates the spirit of the times experienced in our community's rich and diverse past.

Expertly weaving in our city's history, Jack effectively involves the reader through the use of human-interest stories. I was particularly fascinated by two stories: founder James White's generous donation of his turnip patch to be used for the city's first graveyard, and the story of Knoxville's extensive marble industry. In the 1800s Knoxville was known as "Marble City," an honorific title that is well represented in the eloquent craftsmanship of the city's elaborate graveyards, and beautifully illustrated through Aaron's keen use of light and sense of composition. He focuses on the symbolic stories of individuals and the essence of the burial sites.

As I traveled through this book, the character and quietness of each graveyard struck me. In our modern era, we no longer seem to respect the richness that these graveyards represent. They are symbols of the complexities of our history and the simple price of personal achievement and struggles found in everyday life. But in the distance, I can hear the faint click of the camera's shutter capturing the essence of time passing, the sound of pencil to paper documenting those times and their people, elements that make up our community, called Knoxville.

Jack and Aaron truly have voyaged through time to bring us to a moment of reflection.

Stories of Ida Cox, D. H. Holloway, C. C. Williams, Lloyd Branson, A. J. "Pete" Kreis, James Agee, and many more, can become an emotional education for us . . . their lives, their impact, and now the symbols of their demise. I find it tragic that our modern cemeteries do no more for the visitor than list a name and date. What will this mean in fifty or a hundred years to another team like Jack and Aaron who attempt to find history in our future graveyards? What will the stones reveal about ourselves and our times?

The Marble City becomes our storyteller. In a tantalizing way, the reader gains a little insight into the lives of these forgotten people through the photographs and stories told by each statue and marker. Each graveyard proudly outlasts progress and reminds us of the history of Knox-ville and its citizens. Jack pointedly states, "The best places to find strong hints of the city's past . . . and perhaps its true nature—are in Knoxville's graveyards."

Thomas Gray, after whom Gray cemetery is named, wrote in his masterpiece "Elegy Written in a Country Churchyard": "The paths of glory lead but to the grave." After reading Jack's words and studying Aaron's photographs, I am reminded that we ride comfortably into the world nestled in our mother's womb . . . and we leave the world cradled in our Mother Earth's.

Christine Patterson

ACKNOWLEDGMENTS

Thanks to librarians who catalogued countless books, biographical files, genealogical research, and newspapers on microfiche at the University of Tennessee Library, Lawson-McGhee Library in Knoxville, and especially its annex, the McClung Collection. Researcher David Babelay's direction and insights were invaluable.

Thanks also to Robert McGinness, whose comprehensive research into Knox County gravesites, on file at the McClung Collection, was helpful in locating several of these gravesites.

I would also like to thank the staff at the library at First Presbyterian Church and Alix Dempster of Old Gray Cemetery. Background reference work at the University of Tennessee Library was also helpful.

Additional thanks go to Knoxville's weekly, *Metro Pulse*; the work Aaron and I did together for the May 16, 1996, *Metro Pulse* cover story, "The Burial Grounds" inspired this book. And thanks to Aaron Jay, whose idea this was and whose enthusiasm for the project made it seem, at times, almost feasible.

I'm also grateful to my parents, John and Mary Stuart Neely, who long ago sparked my imagination with visits to fascinating graveyards from Charleston to Vicksburg.

▲ ▲ ▲

Finally, thanks from both of us to the families of those memorialized, several of whom have helped us in our work.

Jack Neely

I would like to thank Jack Neely in particular for his faith in taking on this project.

I would also like to thank those whose support and encouragement have made all of the darkroom hours, and this book, possible: Lisa Horstman, for planting the seed of a book in my head, and everyone at *Metropulse;* Rodney Satterfield's help for a young photographer and everyone at Thompson Photo Products for supplying my growing addiction to photography; Alix Dempster of the Old Gray Society; Christine Patterson for her work on the foreword and her passion for the arts; Susan Long's unending patience; Larsen Jay—my brother and longtime friend; to Chris Clavel, my brother-in-arms and co-conspirator; and finally to my parents for their wisdom and care.

Aaron Jay

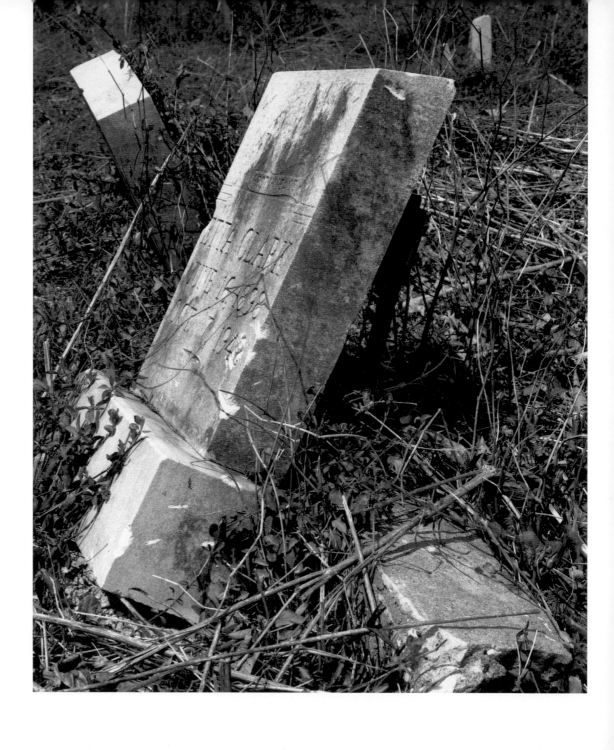

INTRODUCTION

Known today largely as a college town, Knoxville is the third-largest and least famous city in Tennessee. Dispersed into interstate clusters, Knoxville at the end of the twentieth century has become one of America's more suburbanized cities, sustaining hundreds of chain stores and restaurants and nondescript modern subdivisions.

Only parts of its downtown, severed by highway construction in the fifties and sixties, remain intact. One might easily visit Knoxville, or live here, and guess nothing about the city's diverse population or its strenuous, explosive heritage. The frontier capital of the dangerous Southwestern Territory, America's most evenly and bitterly divided city during the Civil War, one of the South's most industrial cities, and, with dynamic musical and literary moments, an artistically cre-

ative city, Knoxville drew thousands from across the country and the world, until it was, by the 1890s, a city more densely populated than Chicago. Knoxville was the often tumultuous meeting place of North and South, of East and West, of agriculture and industry, of city and country, of rich and poor, of black, white, and Native American—of America and itself.

Few physical traces of that Knoxville remain. The best places to find strong, tangible hints of the city's past—and perhaps its true nature—are in Knoxville's graveyards.

Knoxvillians don't visit them regularly, following modern America's paradoxical attitude toward graveyards. We spread them across some of the most beautiful parts of town, landscape and plant them to a perfection we rarely approach in

recreational parks, and give them a degree of permanent protection against redevelopment enjoyed by few other institutions used by the living. And more often in the past, but even today, we take great pains in installing stone memorials that are often the largest and most ornate monuments in the community.

Then, after all that care, craftsmanship, and expense, we ignore them. We rarely visit graveyards at all except to attend burials of relatives or, perhaps, to leave flowers on special occasions. Some regard visiting unfamiliar graveyards as disrespectful or, worse, as bad luck, though certainly our ancestors did not think so. A century ago, Knoxville's finest graveyard was a place for walks and Sunday picnics, a place to witness the wonder of the annual migration of martins, and,

according to one long memory, a fine "courting spot."

In Knoxville alone, billions of dollars and centuries of labor have gone into carving and erecting memorials in the city's graveyards and cemeteries. It seems clear that the stonecarver and the family who hired him meant to communicate with the living—to convey at least a part of a lost life, through words and numbers and symbols and shapes of durable stones, and perhaps to inspire others to follow an example.

That some of these expenses and efforts were in vain is obvious from stones washed clean by decades of weather. Nature makes its own points about mortality. These limestone and marble ruins are often as poignant as the best-preserved granite.

What do we learn from graveyards? Just a glimpse of some huge cemeteries in Knoxville, of course, can be an important reminder of our own mortality we're unlikely to find in popular culture. But there's more to it than that.

Graveyards can also serve as a nonlinear, often astonishing course in American history, and a testament to the diversity found in an urban community, even a small one. In a south Knoxville churchyard are a number of oddly shaped tombstones, many of them homemade, some of them with misspellings. Ten paces away is the

larger grave of another member of the same church: the stylishly artistic tombstone of Paul Y. Anderson, the influential Washington correspondent who won the Pulitzer Prize for Journalism.

In one east Knoxville graveyard is a government-issue Civil War grave for one black man who gave his life for the Union. Nearby is a later grave, perhaps a member of the man's own family, made of concrete perhaps poured on the site, an inscription inexpertly written into it with a stick.

In a cemetery north of downtown, Confederate officers lie within whispering distance of fiery Unionists.

We learn about the history of Knoxville, but we can also read the history of America in the graveyards of this county founded at the dawn of the nation. Knox County's earliest marked burials date from President Washington's administration, before Tennessee was a state, when Knoxville survived only because Indian warriors who could destroy it chose not to. The latest ones were dug just yesterday.

When James White and his allies settled in Knox County in the 1780s, the only evidence that humans had ever lived here were burial monuments: at least three prehistoric Native American burial mounds along the river, already centuries old even when Captain White and the earliest explorers first saw them, and mysterious

to the contemporary Cherokee. At least two of them still survive in Knoxville, along the north bank of the Tennessee River.

In 1793 near one of those ancient mounds was placed what is now the oldest known marked grave in Knox County. It belongs to Elizabeth Carrick, the young wife of the Presbyterian minister who founded the school that later became the University of Tennessee.

Captain White himself established the first permanent graveyard in Knoxville proper when he turned over his turnip patch, beside his fort on the hillside overlooking First Creek, to the city for use as a graveyard and a church. The priorities of the first Knoxvillians are telling: White's neighbors found almost immediate use for the site as a graveyard, but waited over twenty years to build a permanent church adjacent to it. Today, White's old turnip patch contains memorials to several of the new Republic's early senators; veterans of the Revolution and important officers in the War of 1812; Dr. Stephen Foster, a scientist who caused a commotion with his experiments with galvanism; and Samuel Carrick, the founder of a great university. Not to mention Captain White himself, the founder of a city and its graveyard.

Knox County is dotted with the last resting places of the famous and influential. Here is Edward Terry Sanford, a U.S. Supreme Court

justice; there is Pete Kreis, an early Grand Prix racing champion killed at Indianapolis Speedway. Here is Hugh Lawson White, a major-party nominee for the U.S. presidency; there is Ida Cox, a great blues singer of the Jazz Age whose songs are still sung today. Here is William G. Brownlow, the most controversial governor in Tennessee history; there is Ebenezer Alexander, the ambassador to Greece who helped spur on the first modern Olympic Games.

Knoxville graveyards memorialize slaves and slaveholders, professors and paupers, victims of plague and major disasters. Discretely separate graveyards were established to bury the dead of the Civil War. The Union dead of the Knoxville campaign in 1863 formed the nucleus of one of America's first national cemeteries. And the burial of a young Confederate soldier who happened to be Jewish prompted the establishment of Knoxville's first synagogue.

Veterans of every war America has ever fought, in fact, lie buried in Knoxville.

Because graveyards are usually protected from the demolitions and relandscapings and pavings that go along with progress, they generally outlast generations of adjacent development. In Knoxville's case, graveyards are often the only visible remains of more than two centuries of history.

The British-born author Frances Hodgson Burnett lived in Knoxville for a decisive decade of her life: she became a professional writer here, wrote her first two novels here, and based some of her fiction on people and places she knew in Knoxville. Unfortunately, all three of the houses she lived in and most of the "charming little village" of masquerades and boating parties that she knew well have long since vanished. All that remains of her and her family's time in Knoxville is the 1870 grave of her mother—weathered but still legible, in Old Gray.

The loss of seminal American humorist George Washington Harris's Knoxville has been even more complete. His lively stories are anthologized in American literature textbooks studied by undergraduates nationwide. Some of his stories are set in Knoxville, where he was a craftsman, businessman, and politician. But his memory is nearly erased from his hometown. Not only do none of his residences survive; his places of business, the jewelry stores of Market Street, the riverboat *Knoxville* he piloted as a young man, all of it is gone, much of it for more than a century. What does remain are a couple of graves—not his, but those of two of his children. They were buried in the 1840s at what he already knew and remembered in one of his stories as "the old graveyard" downtown.

Graveyards do tend to fare better than other sites, but even they are not invulnerable. Gen. William Pitt Sanders, the young Union general killed during Longstreet's siege of Knoxville, was originally buried in the Second Presbyterian graveyard on Market Street downtown. When that graveyard was redeveloped commercially, Sanders's grave mysteriously vanished. For over half a century, it was lost. After a lengthy search, General Sanders's grave was found in a modestly marked plot in a military cemetery one hundred miles away, in Chattanooga.

▴ ▴ ▴

This collection represents only a few samples of the more than one hundred thousand gravesites in Knox County, Tennessee. We have spent days over the last two years exploring more than forty burial grounds in Knox County, from small family graveyards to huge institutional cemeteries, looking for stories to tell in words and pictures. In all cases we respected the sanctity of the gravesites and did not disturb or alter them in any way for a photograph. We portray them exactly as we found them.

Some are well tended and regularly decorated with flowers. Some are so forgotten they're now remote and overgrown with blackberry and honeysuckle; we had to make our way through thick underbrush just to find some of these. Some are obviously visited daily. In Jewish graveyards, each visitor leaves a pebble on top of the

stone they visit, and in both of Knoxville's Jewish graveyards we always find stones with pebbles on top of them, often several.

If we can read the history of America in Knoxville graveyards, we can also read the history of American burial customs, customs strongly influenced by European thinking.

Following a tradition popular in Europe since the Middle Ages, Knoxville's earliest cemeteries were churchyards—burial places each immediately adjacent to a church and often densely crowded with graves.

First Presbyterian's graveyard, the oldest graveyard within Knoxville's city limits, is most typical of the early Anglo-American approach to burials. The graveyard is directly adjacent to a church, and the graves are crowded together without allowances for garden areas or paths. Today, a modern footpath goes directly over some graves.

Still, it's a bit of a misnomer to call this a "churchyard." As we mentioned, the graveyard was here by itself for over twenty years before the first chapel was built next to it, in 1816. James White, recalled as the founder of Knoxville, built White's Fort just to the north. Originally his hillside turnip patch, in the 1790s he deeded this land for the purpose of establishing both a church and a graveyard. Though the oldest legible grave here is Gov. William Blount's flat 1800 stone, the cemetery was well populated before that time. White formally established it in 1795, but historians speculate that there had already been graves here before then. In 1799, a Moravian missionary, Christian Frederic de Schweinitz, describing adjacent Blount College, noted, "The graveyard also appears to be here, for one sees many graves, but laid out in a very irregular manner. Some individual graves are fenced in; others are without any enclosure."[1] Obviously, the graveyard is years older than all the grave markers we can read. It served as a graveyard not just for Presbyterian church members, but for the city at large. It was, as the elders of the church in 1864 described it in a letter to the occupying Union army, one acre of ground on which "there are many individuals buried of all creeds and colors." One of those buried here was connected to the establishment of the Methodist Church in Knoxville; others weren't known to be regular churchgoers at all. Several graves accommodate more than one person, a practice common in Europe in the eighteenth century.

Such graveyards were central to daily life. The First Presbyterian graveyard was on a busy urban street corner, which around 1800 was a growing residential and commercial area in this state capital. Blount College, the forerunner of the University of Tennessee, was right next door to the churchyard; in fact, the campus and the graveyard were part of the same grant from James White, who lived beside them both.[2]

The state legislature met about two blocks away. Numerous dry goods businesses, taverns,

[1] Enclosing family and individual plots with fencing was a common practice in the eighteenth century, perhaps to discourage treading on graves. By 1850, however, plot fences were going out of style. Many of those that were remaining in this graveyard as late as the Civil War were destroyed or removed during the Union occupation of 1863–65.

[2] Originally located downtown on the block now occupied by the Tennessee Theater, Blount College had been renamed and reorganized as East Tennessee College by the time it moved to UT's present site in 1826. Ironically, in digging the foundation for the first buildings on "the Hill," workers unearthed two human skeletons, first assumed to be Indians. An inquiry disclosed that they were the remains of prominent white Knoxvillians, one of them an important army colonel, buried around 1796 in a graveyard since abandoned. The fact that this graveyard had been so thoroughly forgotten in only thirty years is testament to Knoxville's rapidly shifting population; most of the town's original citizens had already died or moved on.

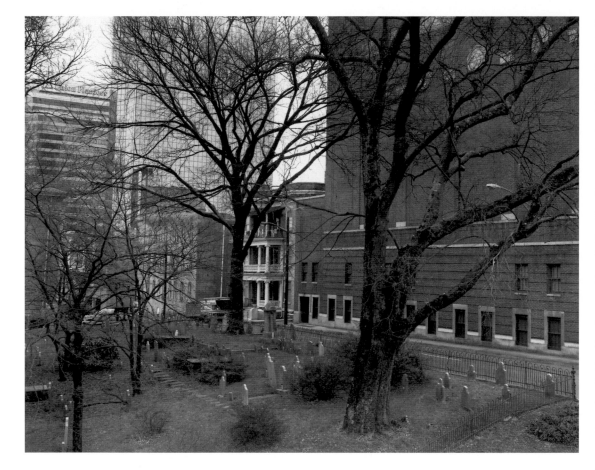

famous nonurban Pere-Lachaise, a new kind of "necropolis" set away from businesses, residences, and even churches. Popularized by articles and drawings published in Great Britain and America, Pere-Lachaise became decisively influential in the development of cemeteries throughout the western world.

Several British reformers, George Frederick Carden (1824), John Strang (1831), and John Claudius Loudon (1843) wrote books calling for a new approach to burials that would separate burial grounds from the commotion of urban life for the betterment of both.

In 1831, the city of Boston took the lead in establishing Mount Auburn just outside of town near Cambridge, a cemetery planned by a botanist and poet inspired by Pere-Lachaise. New York followed in 1839 with Brooklyn's Green-Wood, another semirural cemetery with winding lanes and careful landscaping.

The idea spread rapidly, perhaps aided by fear. In Knoxville's original graveyard, the most common death year on marker inscriptions is 1838. That summer and fall, hundreds of Knoxvillians fell violently ill. Associated with the stench of the dammed millponds of First Creek, the "bilious fever" was sometimes called "malaria," but its actual nature is unknown. The plague of 1838 killed hundreds of Knoxvillians

liveries, and residences were within a minute's stroll of the graveyard. Such a juxtaposition was considered perfectly natural. Several other small graveyards (most of them since removed) sprang up on various busy corners of downtown Knoxville.

Knoxville may have been happy with that arrangement, but Europeans began thinking differently about graveyards. In France and England, when plagues of cholera and other mortal diseases exacted high tolls, reformers suspected that graveyards adjacent to places where people regularly gathered might be bad for hygiene and for emotional well-being. Napoleon banned churchyard burials in 1804, leading to the establishment of the

of all classes. Businesses closed; even the newspaper, after weeks of publishing abbreviated issues made up largely of obituaries, had to cease publication altogether because most of the staff were too weak to run the presses. Though the graveyard at First Presbyterian was used for over sixty years, about one-tenth of the graves legible today date from the plague months of 1838, and at least one of the inscriptions refers to "the fever." The plague led to a rethinking of public health standards in Knoxville. Some of Knoxville's new sanitation measures, like undamming some of First Creek's fetid millponds, certainly helped matters. Fear of the health effects of crowded urban graveyards was exaggerated throughout the western world in the mid-nineteenth century—similar plagues in other American cities had been blamed directly on the fact that people lived and worked near graveyards, which were believed to emit harmful "vapors." Discussion of the plague of 1838 was sometimes deliberately avoided in public forums, but the memory of it may indirectly have hastened the establishment of suburban cemeteries in Knoxville.

By 1850, Knoxville had opened a new cemetery, modeled partly on the French-British "garden cemetery movement." In keeping with the Pere-Lachaise model, its location was a large,

sprawling plot of land that was then barely outside of the city's northwestern limits, a mile distant from the city's business and residential center. To name it, organizers made dozens of bland suggestions, most of them words ending with *wood, vale,* or *dale.* At the suggestion of Henrietta Reese, wife of the president of the university, it was named Gray Cemetery—in honor of Thomas Gray, the English poet, who had died almost eighty years before.

The cemetery once fell into disrepair and has been compromised over the years—some statuary has been broken or stolen, a few graves have been moved elsewhere, and a huge fountain with elaborate iron statuary in the entrance eventually gave way to rust—but, partially restored and now well kept, Old Gray remains one of Knoxville's most beautiful parks. More than any other place in Knoxville, Old Gray reflects the cultural ferment of Knoxville's boomtown years. Those accustomed to thinking of Knoxville as a culturally homogeneous place are sometimes startled at the diversity of cultures represented in the names on stones in Old Gray: Fouche, Zimmerman, Ricardi, Esperandieu, Staub, Gratz. Old Gray was established just as Swiss, German, and other non-British immigrants were gaining a foothold in Knoxville's business and cultural life.

Though some old-fashioned churchyards con-

tinued to be established in the more rural areas of Knox County, with Gray—which would be known by the end of the century as Old Gray—the tide had turned more toward the suburban-style cemeteries we know today. Some later Victorian cemeteries, like Asbury and Woodlawn in south Knoxville and Greenwood in north Knoxville, and New Gray in northwest Knoxville, are also on the Pere-Lachaise model, impressive in size, with elaborate landscaping. But the necropolitan extravagance of Old Gray has never been matched here.

Though Knoxville lagged behind America's larger cities by a decade or more in establishing parklike rural cemeteries, an accident of history put Knoxville in the forefront of another kind of graveyard: the National Cemetery. Before the Civil War, America had never buried its soldiers in a uniform way that reflected their loyalty and military service or with organized records. The National Cemetery movement began by act of Congress in 1862. In late 1863, hundreds of Union men died during the weeks-long campaign for East Tennessee, creating a need for an organized system of burial. Just as President Lincoln was dedicating the Gettysburg cemetery, Gen. Ambrose Burnside was establishing Knoxville's National Cemetery.

Though relatively small, Knoxville's National Cemetery, adjacent to Old Gray, is one of the country's older National Cemeteries, even slightly

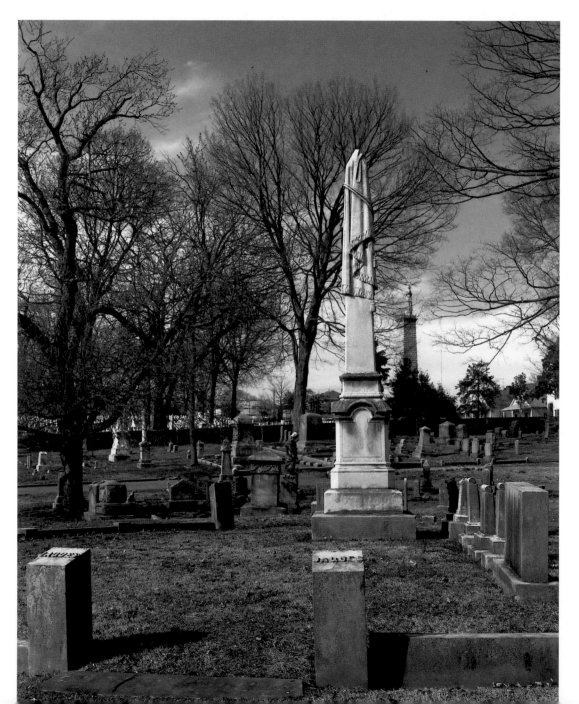

older than America's most famous one, Arlington National Cemetery, near Washington, D.C. (Now augmented by a larger field on Lyons View in west Knoxville, today, Knoxville's National Cemetery contains the remains of soldiers who served in every American war through Vietnam.)

Other graveyards sprang up in Knoxville's boom years, and today they are more conspicuous symbols of the city's Victorian era success in drawing business and population than the period's factories, offices, or opulent homes, most of which have since been demolished.

In particular, Knoxville's more elaborate graveyards represent the city's marble industry; drawing on several quarries in the area, most of them just south of town, the business boomed for several decades after the Civil War, supplying marble for several of the buildings and monuments in Washington, D.C., New York, and other cities. By the late 1800s, Knoxville was known as the Marble City. Knoxville marble was also a source of material for the graves in Old Gray and many other graveyards of this era of elaborate tombstones. Though not as durable as granite, marble is much more malleable; carvings in marble were often more graceful and intricate than granite sculptures and usually lasted at least as long as the people who had known the deceased.

Several small cemeteries that grew during this period are located in one remarkable cluster on the east side of town. In the space of less than one square mile, this area shows the lively diversity of Knoxville in the mid-nineteenth century. With markedly different sculpture—towering angels and crosses and representations of saints—Calvary Cemetery honored Knoxville's nineteenth-century Catholic community. Many were proud of their origins in Germany, Poland, Italy, and especially Ireland; their far-flung birthplaces appear on several of the stones. Backed up against Calvary Cemetery is the fenced Confederate graveyard. Most of its individual burials are unmarked, but there is a flamboyant statue of a soldier at the top of an obelisk. Next to both the Confederate and Catholic graveyards is Potter's Field, where for several decades ending around 1940, Knoxville's poor and unknown were buried. It's marked with a tall shaft and appropriate verses written by the poet for whom Old Gray is named. Adjacent and across a small street is the Oddfellows Cemetery, where many of Knoxville's black citizens are buried, some with homemade examples of folk art decorating their graves. And just a couple of blocks to the north, with some stones inscribed only in Hebrew, is Knoxville's first Jewish graveyard.

In the more rural parts of Knox County—that is, the areas more than two or three miles from downtown—people were less interested in urban trends of landscaping, curving lanes, statues, and flower gardens. Unswayed by urban trends; country people followed the old ways, burying their dead in either of two styles: in the country churchyard, adjacent to a church, some of them begun after Knoxville and many American cities had abolished churchyard burial; and in the family graveyard, often on a hilltop near the residences of the families who used it. These patterns continued into the twentieth century, until the post–World War II era, when the great majority of burials occur in large, minimally decorated "memorial parks." Highland in west Knoxville and many others farther out in the country are examples of this type. These have advantages, such as ease in mowing and less temptation to thieves or vandals. The fact that modern graveyards are less expensive per gravesite also reduces the hazard of bankruptcy, which always has tragic consequences, as at least one cluster of bankrupt graveyards in northwest Knoxville indicates. These graveyards are overgrown, and many of their stones are toppled or missing, and many coffins have been exhumed and reburied elsewhere, leaving gaping holes.

However, except for a few eccentrics who leave provocative messages on their stones—one west Knoxville grave of a young man who died in 1986 claims, "HE WAS NEVER BORING"—modern cemeteries do not reward the casual visitor with much more than what a typed list of names and dates might. Consequently, modern cemeteries are generally not regarded as interesting places to visit. And this is a shame, because it's not just cemeteries, but the motive to visit them, that gives us the perspective, the sense of belonging, the sense of place we find in the older ones.

All graveyards teach us history. Knoxville graveyards have been known to *influence* history, especially where history touches American literature. A scene at Greenwood Cemetery in north Knoxville became one of the most vividly memorable images in James Agee's Pulitzer Prize–winning novel, *A Death in the Family.* Another arresting scene in Old Gray, also based on a true story, opens *In the Tennessee Country,* the final novel by another Pulitzer-winning author, Peter Taylor. Still another scene at Old Gray inspired a bittersweet essay by playwright Tennessee Williams widely published as "The Man in the Overstuffed Chair."

And Adolph Ochs, the influential publisher of the *New York Times,* once claimed that the Presbyterian Church graveyard downtown, which was near his family's Central Avenue home, inspired his career in journalism. Work-

ing the night shift at the *Knoxville Chronicle,* Ochs so feared his walk home by the graveyard at midnight that he was willing to work extra hours at the paper and learn other jobs. He claimed that fear inspired him to learn the newspaper business better than anyone else on staff. "Perhaps the cemetery had something to do with it," concludes Ochs biographer Gerald Johnson in his book, *An Honorable Titan.* "If ghosts could inspire resolution in a fainthearted prince of Denmark, why not in a stouthearted proletarian of Tennessee?"

In this quietly diverse community once known as Marble City, monuments to the dead can still inspire the living.

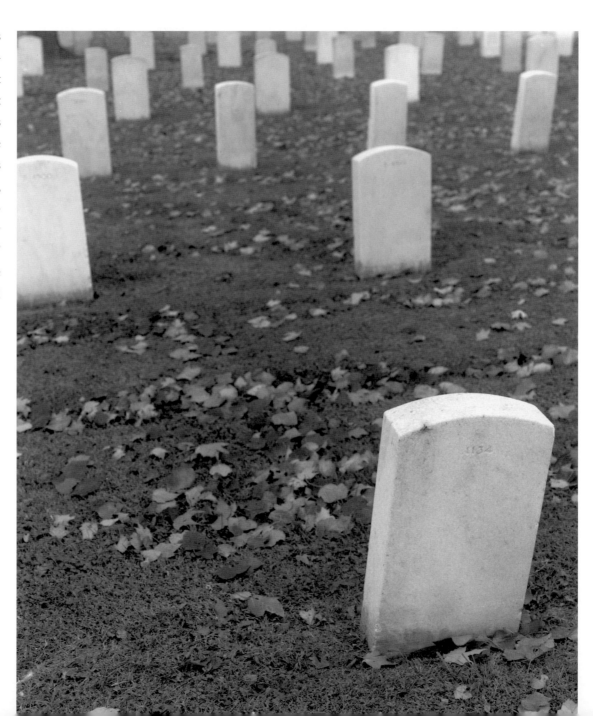

The MARBLE CITY

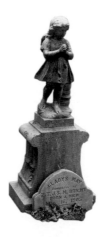

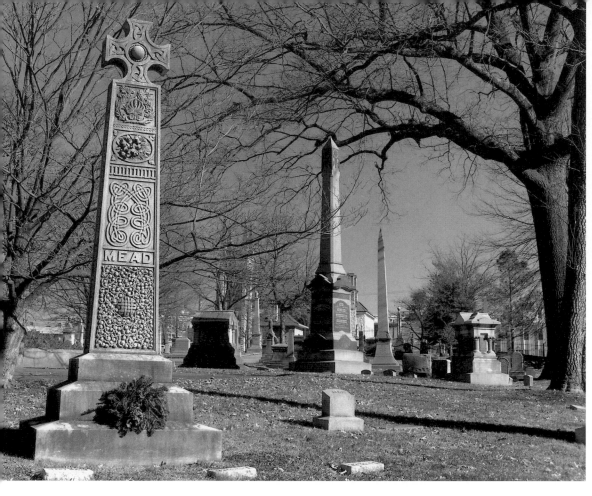

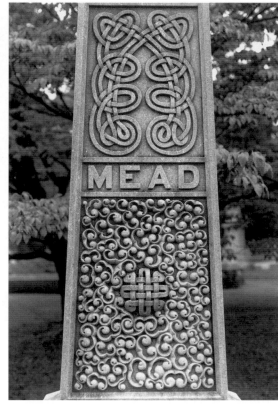

This remarkably ornate marble carving in Old Gray Cemetery reflects one of Knoxville's chief industries, and the career of one of those memorialized here. Born in New York during the Civil War, Frank Seymour Mead moved with his parents to Knoxville, where his father got involved in Knoxville's postwar iron industry. Frank Mead had other ideas, and became one of the pioneers of Knoxville's growing marble indus-try. Mead's Ross-Republic Marble Co., of Island Home, was known for the marble monuments it supplied to several major cities.

Other members of his family met unusual fates. Frank's older brother, Arthur, was a young man in the 1890s when he was killed in a sled-ding accident on Cumberland Avenue. His mo-ther died unexpectedly on an extended trip to Italy in 1900. Eight years later, his seventy-five-year-old father was hit by a streetcar in New York and died there. All are buried right here at Old Gray. Frank Mead, by contrast, died quietly in his large Laurel Avenue home in 1936. Though rarely mined today, Mead's quarry remains a south Knoxville landmark.

Carved by local marble sculptor D. H. Geddes, the Mead grave appeared in photographs promot-ing Knoxville's marble industry in the 1920s.

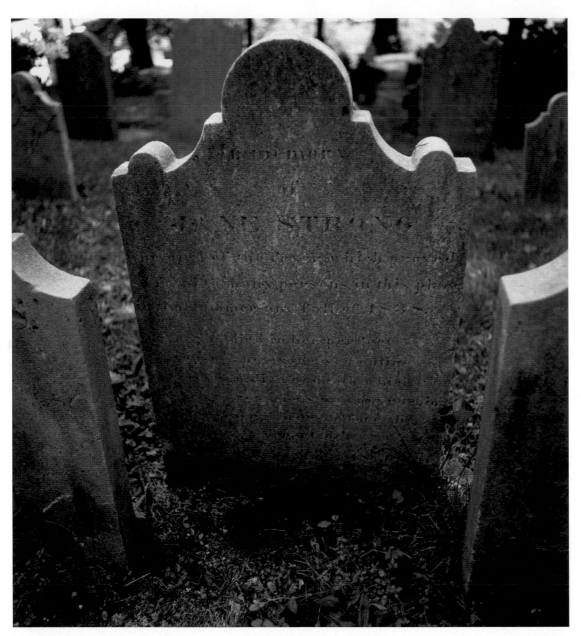

Knoxvillians of several denominations buried their dead at the graveyard at First Presbyterian Church for well over fifty years. However, more than 10 percent of the graves legible today date from a single year: 1838.

The Epidemic of 1838—sometimes called the Malaria, the Bilious Fever, or the Pestilence—may have killed one in ten Knoxvillians over its three-month reign. Among the dead were many prominent citizens, including the minister of this church. Some twenty graves in this churchyard date from the plague months, but this weathered stone, which commemorates a young woman named Jane Strong, is the only grave that mentions "the fever" in its engraving.

What is, in national directories, one of Knoxville's most famous gravesites is not one of the city's more conspicuous ones. Originally from Georgia, Ida Cox was a child performer in vaudeville and spent much of her life touring the cities of the North, becoming nationally famous as a blues singer. Hailed in the 1920s as the "uncrowned queen of the blues" and often grouped with her contemporaries Bessie Smith and "Ma" Rainey, Cox sang with the jazz legends of her day: King Oliver, Louis Armstrong, and Jelly Roll Morton, to name a few. Different from most female blues singers of her generation in that she wrote many of the songs she sang, she cut scores of 78 RPM singles. Her best-known song was probably "Wild Women Don't Have the Blues," which has since become a favorite epithet on bumper stickers and book titles.

After she suffered a stroke around the age of fifty, Cox retired and found religion. She swore off the blues and spent the last twenty years of her life in east Knoxville, living with her daughter, who had moved there. Her only singing was done as a member of the choir at the Patton Street Church of God. Cox's disappearance from the big-city blues scene was so complete that, by the 1950s, many of her old show-business friends and colleagues believed she had died. However, in 1960, the prodigious musical impresario John Hammond discovered Ida Cox living quietly in Knoxville and persuaded her to come to New York for one more recording session with jazz greats Coleman Hawkins and Roy Eldridge. Her unlikely comeback was heralded by a profile in the *New Yorker:* "Guess who was in and out of town last week, and after a 20-year absence, at that!"

Untempted by offers to revive her career after this one critically hailed album, *Blues for Rampart Street,* Ida Cox returned to Knoxville, where she died of cancer in 1967 at age seventy-three. The article about her death in the *New York Times* was longer than her obituaries in the Knoxville papers.

One recently published *National Index of Gravesites of Notable Americans* states that Ida Cox is buried at Longview, which was a small black cemetery off Keith Avenue. Originally, she was buried there. However, that cemetery fell into disrepair after it went out of business. Many who could afford it reinterred their dead elsewhere. Ida Cox is now buried in a single plot just over the ridge from Longview, in one of the plainer parts of New Gray Cemetery, on Western Avenue. Her stone says nothing of her national fame, but is inscribed MOTHER. To her, it was probably the most important role she played in her later life.

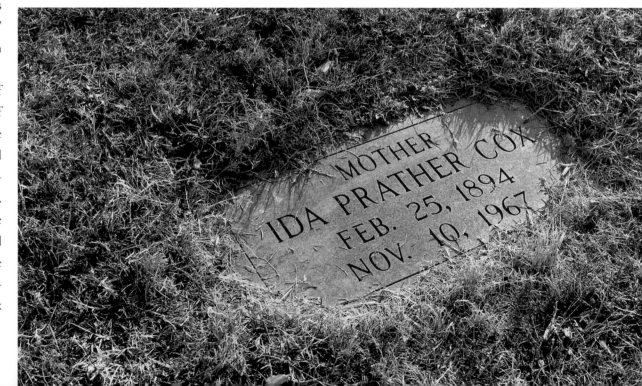

Victorian tombstones sometimes render clues about the manner of death of a decedent. Many victims of train accidents are buried at Old Gray, including several from the famous New Market Train Wreck of 1904, one of the worst disasters in East Tennessee history. Few stones are as vivid as Davy Holloway's.

In 1875, spring floods in the Chattanooga area undermined a number of bridges over the Tennessee River. After emergency repair work had been done on one bridge owned by the East Tennessee–Virginia–Georgia Railroad— the forerunner to Southern Railroad—one road-master insisted it was safe. Many were skeptical,

including thirty-one-year-old David Humphreys "Davy" Holloway, the engineer of the first train that was to cross it. He detached the cars from his engine and coal tender and even insisted that his fireman get off the engine before it ventured across the bridge. As a delegation of railroad employees watched, Holloway's engine chugged onto the bridge, which gave way beneath it, and Holloway and his engine plummeted to the bank below. Workers were not able to free Holloway's body from the crushed engine for days; repair work on the bridge was apparently completed while the engineer remained entombed in his engine below. An overflow crowd attended Holloway's funeral at the Methodist Church. The engines in the East Tennessee–Virginia–Georgia roundhouse in downtown Knoxville were draped in black in Holloway's honor.

Holloway's accident is rendered literally in this bas-relief, even to the detail that the bridge was reportedly supported by only one trestle. The prominent compass indicates Holloway's allegiance to his Masonic lodge.

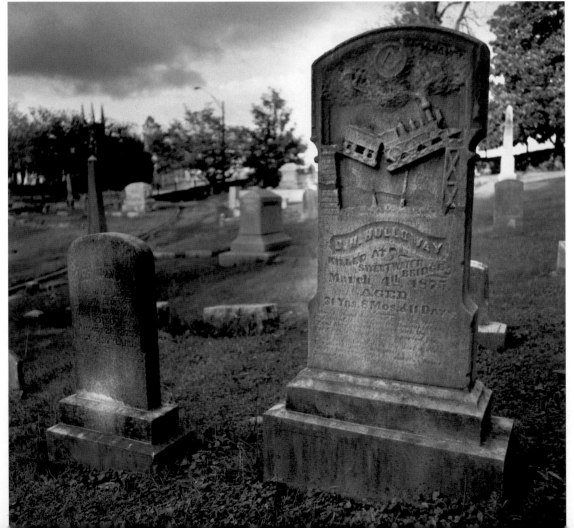

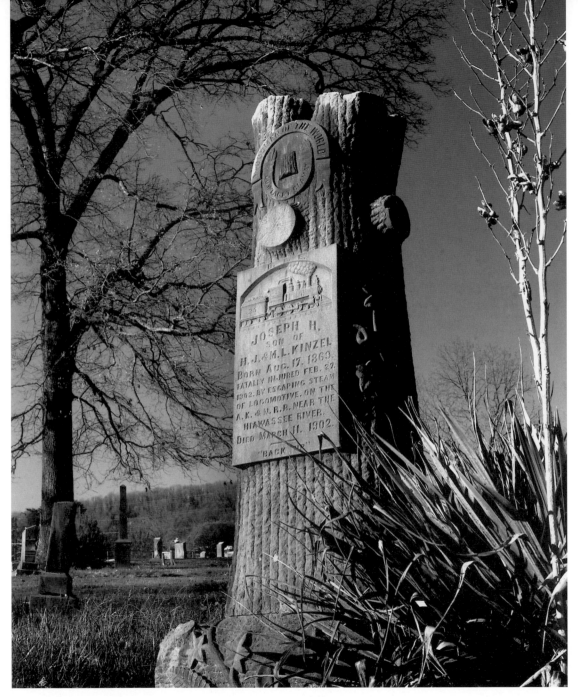

Originally from Germany, the Kinzels were a railroad family. Joseph "Joe" Kinzel was an engineer for the Atlanta, Knoxville, and Northern Railroad. On February 27, 1902, he was taking the A.K. & N. No. 13 on a freight run to Marietta, Georgia, when he saw a landslide covering the tracks ahead. He attempted to reverse the engine—hence the words "BACK UP" inscribed here, probably Kinzel's last words before the accident. Kinzel's fireman jumped and survived the wreck, but the No. 13 derailed down an embankment toward the Hiwassee River. The engine split in the wreck, and the escaping steam severely scalded Kinzel. Brought back to Knoxville, Kinzel died twelve days later. This stone with unusual detail about his accident is in the churchyard at Miller's Lutheran in northeast Knoxville.

These stump markers are examples of the work of the International Order of Woodmen of the World, a social organization that benefited its members with an umbrella group insurance policy that included these distinctive grave markers. Though still in business in the late twentieth century, the Woodmen were more conspicuous around 1900, and their stump stones are evident in many turn-of-the-century graveyards.

Planned in the 1890s on a model similar to Old Gray's but much larger, Greenwood Cemetery on Tazewell Pike was inspired by a grieving parent, R. N. Kesterson, who needed a place to bury a young son, who died in 1890. Kesterson, a successful dentist, and his wife traveled the country studying cemetery design and returned with an idea for this one. They called it Greenwood, probably after the 1839 landmark cemetery in Brooklyn, New York.

On a hill overlooking Greenwood, the forty-five-foot-tall Kesterson marker can astonish first-time visitors. Installed in 1928, this obelisk was reportedly the second-tallest solid granite shaft in America at the time. (John D. Rockefeller's monument to his family was taller.) It remains the tallest burial monument in the Knoxville area. Dr. Kesterson himself died in 1931, and he is buried here.

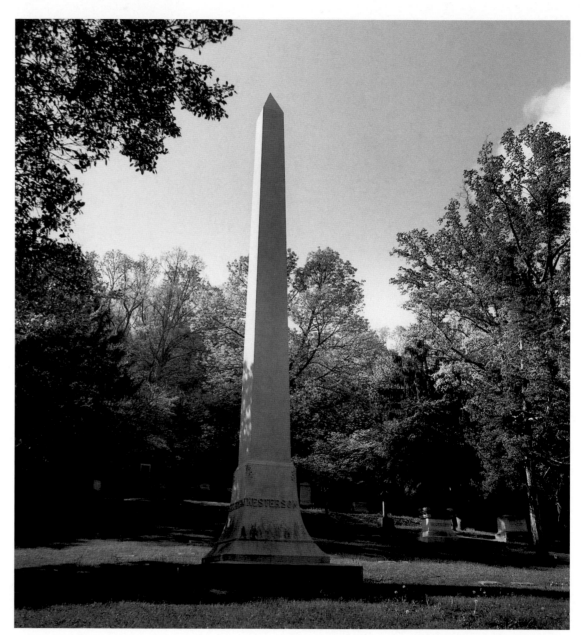

Hauled by train from a Georgia quarry, the first shaft quarried was unloaded from a special flatcar in Knoxville. The granite company quarried another obelisk for Kesterson. What remained of the upper portion of the original Kesterson monument was passed to members of the McClung-Berry family—known as sponsors of UT's McClung Tower—who used this fragment as a central monument for their family plot farther down the hill.

He saw in his mind a clear image of Greenwood Cemetery; it was on a low hill and among many white stones there were many green trees through which the wind blew in the sunlight, and in the middle there was a heap of flowers and beneath the flowers, in his closed coffin, looking exactly as he had looked this morning, lay his father. Only it was dark, so he could not be seen. It would always be dark there. Dark as the inside of a cow.

—James Agee, *A Death in the Family*

A sometime postal employee who had lived in Panama, the young man buried here was a father of two who lived with his family in a comfortable home on Highland Avenue in Fort Sanders. In April 1916, he drove his car off the road along what is now Clinton Highway, hit his head, and died instantly. More than forty years later, his life and death were vividly remembered in a book written by his son. James Agee, who bore his father's name, was only six when his father died; biographers believe he never recovered from the loss. For most of his adult life, the maverick journalist and screenwriter worked on a story about his father's death. Today, this tender but unflinching account of death seen through the eyes of a child is an American classic.

Though *A Death in the Family* is technically a novel, it's apparent that little in it was invented except for the names of the characters. James "Jay" Agee became Jay Follett, a name likely suggested by LaFollette, Tennessee, the Agees' ancestral home. Agee never finished the book to his satisfaction. But after his own death in 1955 at the age of forty-five, his editors recovered the manuscripts and published them. *A Death in the Family* won the Pulitzer Prize for Literature in 1957. Later, playwright Tad Mosel wrote the story into a play called *All the Way Home,* which won the Pulitzer for Drama in 1960. Still later, it became a movie of the same name, starring Robert Preston as Jay Follett.

In the book, Rufus's Uncle Andrew is furious at the minister who refused to offer a full burial service because the elder Agee, an agnostic, had never been baptized. A cloud obscures the sun as the coffin is being lowered, and a butterfly lands on top of it, moving its wings in a rhythmic fashion that reminds him of a beating heart. When the coffin grates at the bottom of the hole "like a rowboat," the sun shines again as the butterfly soars out. "If anything ever makes me believe in God," Uncle Andrew comments to the boy Rufus, "or life after death . . . it'll be what happened this afternoon."

Judging by the death dates on other stones, the elder James Agee was nearly alone when he was buried in this part of the then sixteen-year-old cemetery. He was never joined by any members of his family; his widow moved away and remarried. His famous son is buried at the farm the author owned in New Jersey.

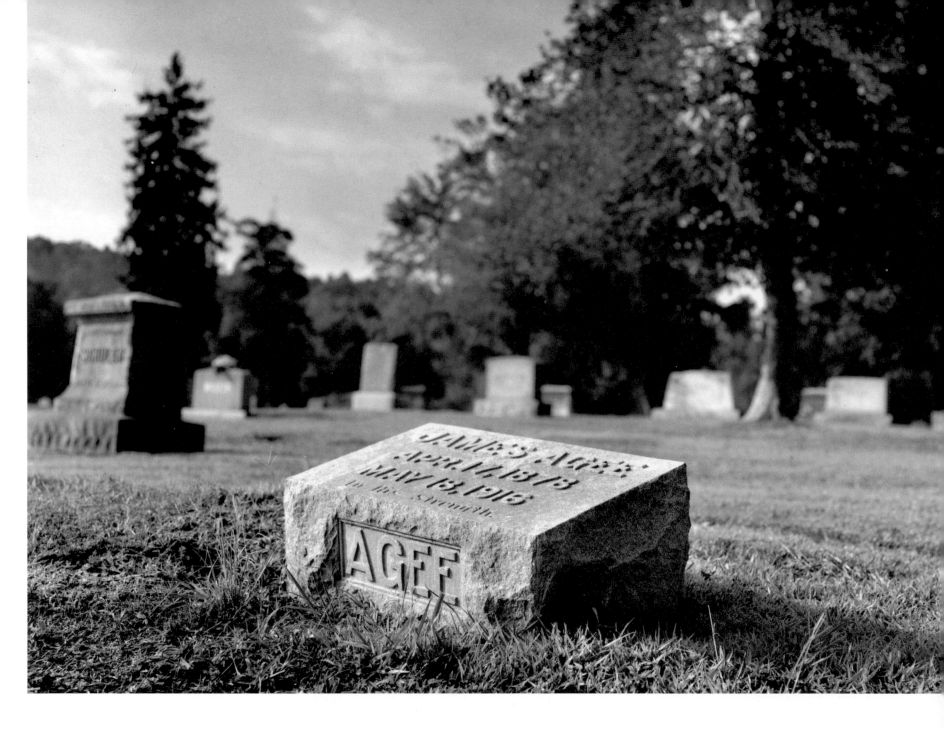

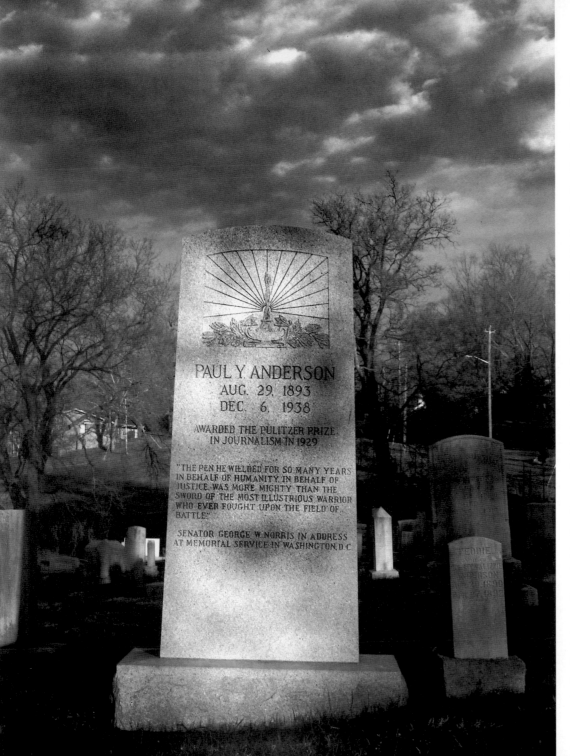

Recalled by some Washington journalists as one of the most fearless newspaper reporters of the century, Paul Y. Anderson's name is curiously absent from most lists of famous Tennessee writers. Anderson's father, a Knoxville marble stone-cutter, was killed in a quarry accident when Paul was a little boy. Paul grew up in poverty in south Knoxville, and as a teenager found work reporting for the *Knoxville Journal.* Offered a job with the *St. Louis Post-Dispatch,* he became that paper's Washington correspondent. Known for a tenaciousness and almost reckless lack of regard for his own safety, Anderson covered race riots and murder investigations, challenging corporate presidents, organized-crime bosses, and, eventually, Republican presidents. In the 1920s, Anderson's reporting exposed much of the Teapot Dome scandal. For his efforts, Anderson won the 1929 Pulitzer Prize for Journalism.

Facing several personal problems including alcoholism and a failing third marriage, Anderson committed suicide in Washington in 1938. Heywood Broun, legendary reporter for the *New York World-Telegram,* called Anderson "the finest journalist of his day."

This elaborate marker with art-nouveau stylings, is the largest stone in the otherwise modest churchyard of Island Home Baptist. The small stone to the right memorializes his first-born brother, who died at age two before Paul was born.

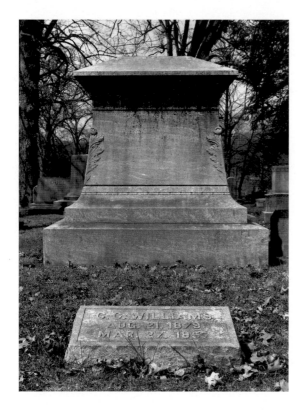

Cornelius Coffin Williams was born and raised in Knoxville and educated at the University of Tennessee. Shortly after the turn of the century, he moved to Mississippi, married, and had three children.

He named his first son Thomas Lanier Williams after the child's grandfather, a prominent Knoxville lawyer and politician who is also buried in this plot. Cornelius's son grew up to be a successful playwright, better known by his nickname, "Tennessee."

Rarely content with family life in Missouri, Cornelius Williams frequently returned home to visit his sisters. Late in life, he wandered back to Knoxville, living with a mysterious woman his family knew only as the Toledo Widow. He died here in 1957. Tennessee Williams, known for *The Glass Menagerie* and *A Streetcar Named Desire,* was already one of the world's most famous playwrights. He came to Old Gray for the burial. Tennessee Williams's relationship with his father had always been strained and apparently provoked some conflicting feelings. Though the playwright, dressed in a white linen suit and sunglasses, struck some witnesses as cavalier about the event, his father's death and funeral sent him into a melancholy reverie that biographers say resulted in his next play, *Suddenly Last Summer.* It also prompted him to write an essay about his father and the burial at Old Gray entitled "The Man in the Overstuffed Chair."

"The funeral was an exceptionally beautiful service," Williams wrote in that memoir he chose not to publish until near the end of his life. "Then we went out to Old Gray, as they called the Knoxville Cemetery, and there we sat in a sort of tent with the front of it open, to witness the interment of the man in the overstuffed chair. . . . Behind us, on chairs in the open, was a large congregation of more distant kinfolk and surviving friends of his youth, and somewhere among them was the Toledo Widow, I've heard. . . . The widow drove off in his car which he had bequeathed to her, his only bequest, and I've heard of her nothing more."

A veteran of the Union Army, Capt. William Rule led one of the most remarkable careers in Knoxville history. Upon returning from the war, he became a prominent editor with Parson Brownlow's Knoxville newspapers. In all, he was a newspaper editor for more than sixty years and was twice mayor of Knoxville.

Until he died at the age of eighty-nine—after a sudden attack of appendicitis—Captain Rule was still the working editor of the daily *Knoxville Journal.*

Of all Rule's own former employees, his most famous alumnus was Adolph Ochs, then publisher of the *New York Times.* Unable to attend Rule's funeral, Ochs visited this grave in Old Gray in 1929. A photographer for Rule's paper, the *Journal,* attempted to capture Ochs at this sentimental moment, but Ochs declined to be photographed, citing his superstitions about graveyards.

Rule was buried at Old Gray, near the monument to his longtime editorial boss, "Parson" William Brownlow.

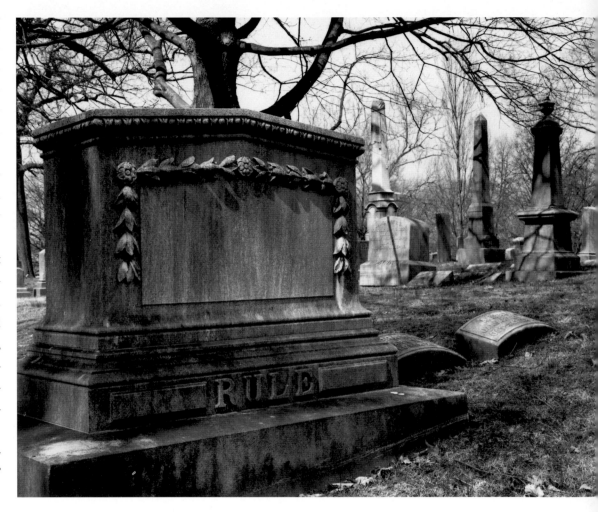

This oddly vacant plot in Old Gray, marked only with a step inscribed TAYLOR, was the focus of a 1912 burial service that drew an estimated 40,000 mourners and was reportedly the largest funeral service in the history of the South. The decedent was Robert Love Taylor, former governor of Tennessee and, until his death, a U.S. senator. He captured the hearts of Tennesseans not only by his Democratic politics, but also by his inspirational speeches, which often drew overflow audiences, and by his skill as a fiddler, which is recalled as influential in the popularization of country music.

When the Pulitzer Prize–winning author Peter Taylor wrote his final novel, a book about a missing cousin and a family secret, he used a slightly fictionalized account of the Robert Taylor funeral as its centerpiece. In that novel, *In the Tennessee Country,* Sen. Robert Taylor becomes Sen. Nathan Tucker, and at his huge funeral in a Knoxville cemetery, a shadowy cousin vanishes. Like much of Taylor's fiction, the novel is largely autobiographical. Taylor recalls the funeral and the exhumation and reburial of Taylor's remains in the 1930s, as if he had witnessed it:

By the time we arrived at the Knoxville cemetery I was so weary of events that I refused to take notice of anything that went

on. . . . I saw little of the ceremony and did not take notice of the coffin being lowered into the grave. In fact I have no memory of the event at all, unlike the occasion of that gruesome event twenty years later when, during the exhumation (and before its second interment in another cemetery a hundred miles up the valley) I witnessed the breaking loose of the clay-covered coffin from the crane lifting it from the grave. But although I didn't remember any of the earlier event, in later years I was told I behaved strangely, as if in a presentiment of that later event.

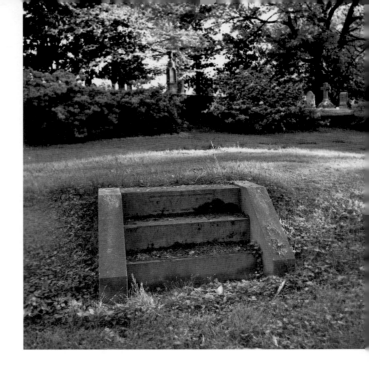

Like Agee's *A Death in the Family,* Peter Taylor's novel is based on fact and revolves around a funeral and burial told partly from the point of view of a child. However, these memories of the burial at Old Gray were not Peter Taylor's own. Because the novelist was not born at the time of Robert Taylor's first burial at Old Gray, his narrator is a few years older than he was, and the "Tucker" burial date was pushed forward four years—to 1916—in order for him to more easily imagine witnessing it.

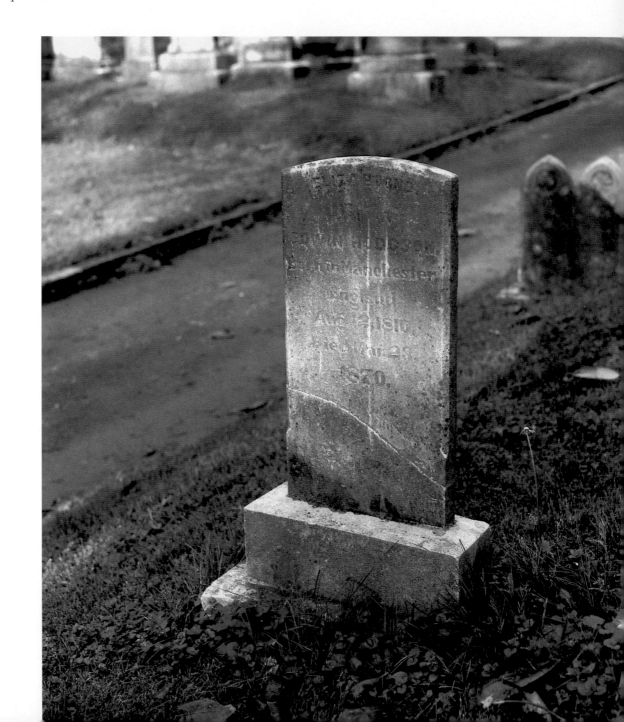

ELIZA BOOND
WIFE OF
EDWIN HODGSON
BORN IN MANCHESTER, ENGLAND.
AUG. 12, 1810
DIED MAR. 23, 1870.

In March 1870, a middle-aged English widow named Eliza Hodgson died in her home in downtown Knoxville. She had moved to Knoxville from England five years before to seek the support of her brother, William Boond, who kept a store here. She brought with her several children, including a teenage daughter, Frances, or Fannie.

All of the children had to find work; one as a musician, one as a bartender, one as a piano teacher. The family lived in various places, but settled in a large but dilapidated old house near the river. Her romantic children called it Vagabondia, and they continued living there after her death. The old house became a gathering place for the Hodgsons' friends, many of whom were musicians and artists.

Eliza Hodgson's twenty-one-year-old daughter, Frances, already a published magazine writer, kept churning out stories for American women's magazines, and on the side she began working on novels for a general audience. Her first, called *Vagabondia,* was set in Bloomsbury, London, but is believed to be autobiographical and includes descriptions of her brothers and friends in Knoxville, circa 1870.

Fannie Hodgson, who occasionally wrote travel pieces for the *Knoxville Chronicle,* married a local physician, Swan Burnett, who had an of-fice on Gay Street. She gave birth to the first of their two sons here before moving to New York and Washington in 1877. She was ever after known as Frances Hodgson Burnett, the name by which she became famous in England and America as the author of children's novels like *The Secret Garden, Little Lord Fauntleroy,* and *Sarah Crewe.*

When Eliza died, her children buried her in the part of Old Gray favored by those who did not wish to buy family plots. The very young Hodgsons may have suspected that they themselves wouldn't be buried in Knoxville, but it's also likely that they weren't able to afford anything more. The phrasing of the stone is somewhat unusual, using Mrs. Hodgson's maiden name but with more prominent mention of her husband, Edwin Hodgson, who never lived in America and had been dead for many years; the children may have wished to have a place to remember him, too.

Though one of Eliza's sons, Bert Hodgson, led a band popular at Knoxville balls into the 1880s, the Boond-Hodgsons eventually moved away. Today this lone gravestone in Old Gray is the only landmark of the Hodgson family's lively years in Knoxville.

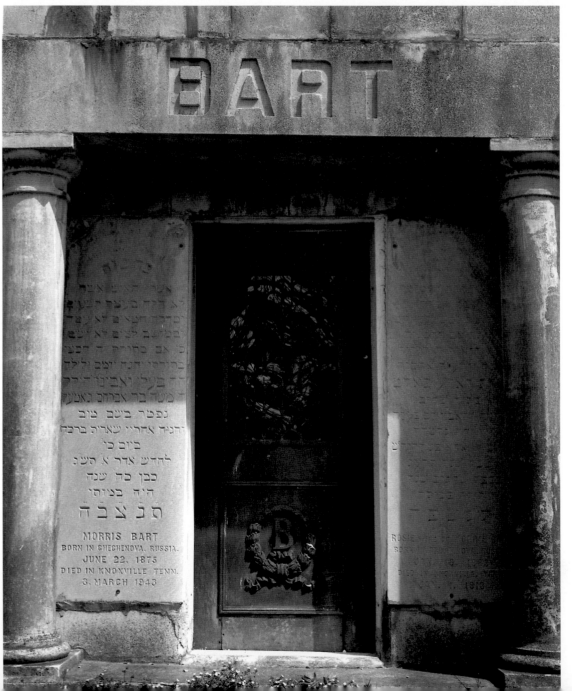

MORRIS BART
BORN IN CHECHENOVA, RUSSIA.
JUNE 22, 1875
DIED IN KNOXVILLE, TENN.
3. MARCH 1943

This impressive mausoleum in the Jewish grave-yard in northwest Knoxville, honors Morris Bart, who came to America as a boy from Chechenova, Russia, spending part of his youth in Lake City, Tennessee.

Bart came to Knoxville in the 1890s, working downtown as a street peddler, selling merchandise from a pack on his back. He eventually opened his own store and lived in a comfortable home on fashionable North Fourth Avenue. He and his New York–born wife, Rosie, lived there with their small daughter, until the twenty-nine-year-old Mrs. Bart died, on New Year's Day, 1913. The grieving widower built this elaborate tomb with Hebrew inscriptions for her. By that time, Morris Bart's aged father Gutel—a veteran of the czar's army, who in 1931 claimed to be 114 years old—had moved in with his son in Knoxville. (He's buried nearby.) The elder Bart spoke four languages, but not English.

A man with international interests, Bart directed the Armenian Relief effort in Knoxville during World War I and was also in charge of war bonds sales in the Knoxville area. Bart was also a founding member of Heska Amuna Synagogue, Knoxville's first Jewish Orthodox congregation. Bart later bought the Newcomer Depart-

ment Store and owned hosiery stores in Knoxville and Harlan, Kentucky.

Though he later remarried, Bart was interred here with his first wife, more than thirty years after her death. Like many graves in this graveyard, it's inscribed in both Hebrew and English.

Some graves here also include the month and year by the Jewish calendar.

Though over a century old, this graveyard is still known as the New Jewish Cemetery—to distinguish it from the Civil War–era one in East Knoxville.

Many of the Americans killed in World War I
died in the war's final bloody weeks.

Richard H. Dickson, a graduate of old Park
City High in east Knoxville, was living with his
widowed mother on Linden Avenue when he
enlisted in the U.S. Army in 1917, soon after
America joined the war. He was in combat in
Europe for much of the following year. Six weeks
before the armistice that ended the war, some-
where near Bellicourt, France, Corporal Dickson
and two other enlisted men from Knoxville were
killed in action.

As was often the case, his friends and family
did not hear of his death until weeks after it hap-
pened. By early November 1918, Knoxville news-
papers were already speculating about the terms
of the peace treaty. Corporal Dickson's obituary
was announced in the newspaper on Saturday,
November 9—two days before the Armistice.

Dickson, who may have seen poison-gas as-
saults and the worst of modern warfare, is bur-
ied in the old Lebanon-In-the-Fork churchyard,
near veterans of the Revolutionary War.

Jan Lynch, an ordained priest and bishop who spent much of his clerical career in Europe, was also a professional photographer known for his controversial subject matter. This unusually large stone at the Anderson-Gouffon Cemetery off Tazewell Pike includes an inscribed photographic portrait of the deceased on this side. The other side is just as striking for what is inscribed there. After his death of AIDS at the age of forty-five, his family discovered that during his sojourns in Europe, Lynch had earned a number of exotic honors and had his grave inscribed to reflect them. Beneath a stylized double-headed eagle, the stone reads, in part:

HIS GRACE, THE MOST REVEREND

JUSTINIAN JAMES HARRILL LYNCH, III

BISHOP OF PETRA IN EGYPT

COUNT OF TRABZON

CAVALIERE DI GRAZIA MAGISTRALE

SOVEREIGN MILITARY HOSPITALIER . . .

ORDAINED A PRIEST IN THE BYZANTINE RITE

AUGUST 28, 1977, TORONTO, ONTARIO

CONSECRATED BISHOP MARCH 1988, PARIS, FRANCE

DIED IN KNOXVILLE, TENNESSEE, NOV. 6, 1996.

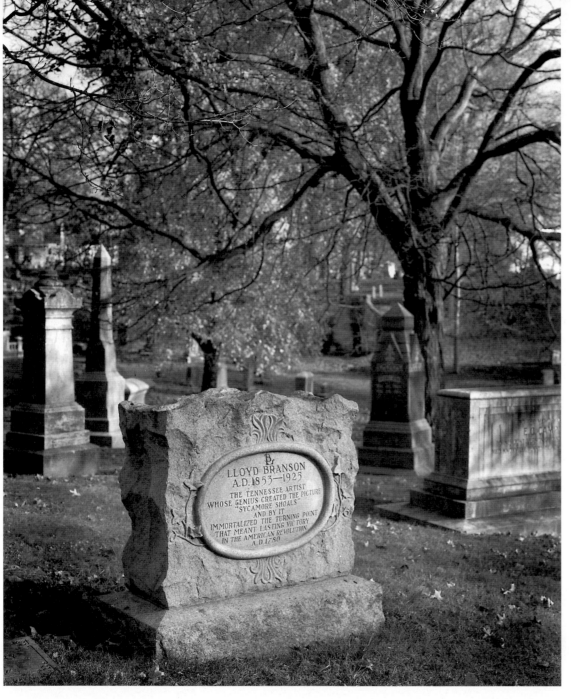

Lloyd Branson made his living working in the studio of McCrary and Branson, a photographic and painting studio that specialized in portraits, but he became known around the region for his more serious work.

When he was a boy, a local doctor had been so impressed with Branson's talent—shown, according to legend, in a sketch he made of General Grant during the war—that he sent him to art school. Branson became a stylistically conservative but still daring painter, with several important paintings to his credit. *The Toilers*—a.k.a. *The Hauling of Marble*— a French-influenced picture of industrial effort in the Knoxville area, was a big hit at the Appalachian Exposition of 1910. He was also a sometime sculptor whose model inspired the romantic depiction of a mustachioed soldier that overlooks the Confederate Cemetery from its lofty pedestal.

Branson, whose paintings are occasionally reproduced in art books, has a solid reputation as an important regional artist in his own right. However, he became more famous seventy years after his death for his influence on another young painter, the Knoxville-born artist Beauford Delaney. Perhaps remembering the favor a local doctor had done him, Branson hired the talented young man as an apprentice and later sent him to art school in Boston, commencing Delaney's remarkable career in New York and Paris.

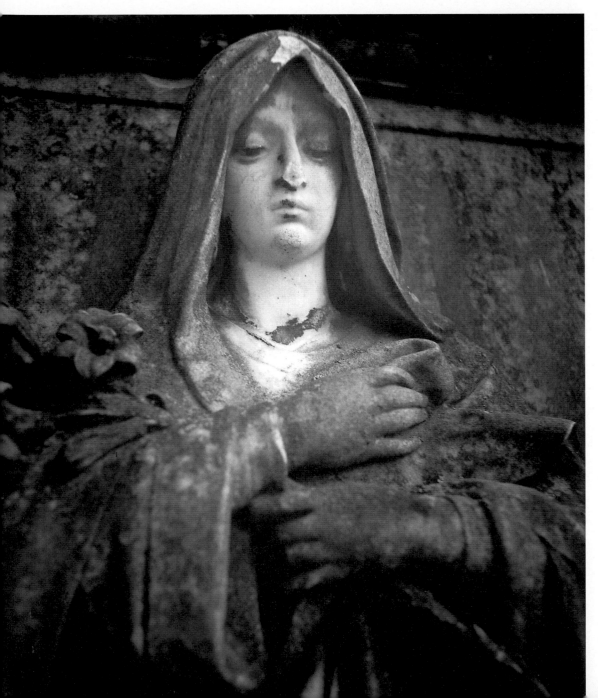

This melancholy figure memorializes the Swan family, parents of Eleanor Deane Swan Audigier. An art collector and aspiring artist, Mrs. Audigier became the moving force behind a remarkable cadre of Knoxville artists, most of them strongly influenced by French Impressionism—among them, Lloyd Branson, Catherine and Eleanor Wiley, and Charles Krutch. Known as the Nicholson Art League, their manifesto was that "the office of art [is] to educate the perception of beauty." The league's work reached its apogee with its group art show at Knoxville's Appalachian Exposition in 1910.

At forty-seven, Eleanor Audigier moved to Europe with her husband. Though some artists at the Nicholson Art League developed lasting reputations, the group never had the influence and vigor it had enjoyed under Mrs. Audigier's direction. She spent the rest of her life in Rome, with occasional visits to Knoxville.

Mrs. Audigier had this memorial to her parents carved in 1929 by Italian sculptor Antonio Bebelotti, who had carved public monuments in Rome; she said the Carrara marble used was mined from a vein used by Michaelangelo. She died two years later, as the stone indicates, in Rome. Mr. Audigier had her body returned to Old Gray for burial with her parents. The sculpture is called *Peace*.

In many parts of the South, it was once an African American tradition to smash plates and other belongings of the deceased at the gravesite—a ritual believed to free the spirit of earthly ties. This uninscribed concrete grave, located in East Knoxville's Oddfellows Cemetery, is imbedded with broken glass and even shards of fine china— a bit of folk art that may echo that earlier tradition. Hardly any records of the Oddfellows Cemetery survive; the identities of many of those buried here will likely remain unknown.

Opposite: Perhaps the most common symbol seen in American cemeteries today, the Christian cross was rare among Protestant graves before the Civil War. No known early Knoxville graves are marked with crosses. Condemned as a "graven image" by American Protestants, the cross was originally used on burial monuments only by Catholics, who were not numerous in Knoxville before about 1850.

The cross became popular among all Christians in the late Victorian era. However, most of these crucifix images come from Calvary Cemetery, Knoxville's oldest Catholic graveyard.

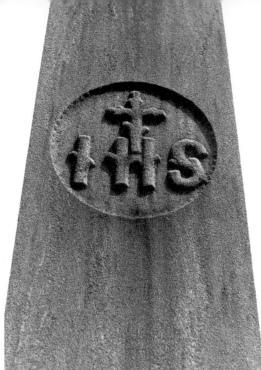

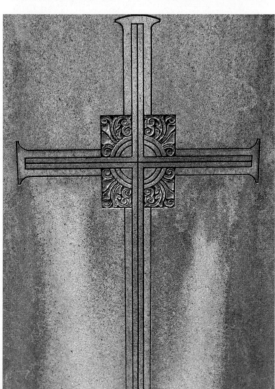

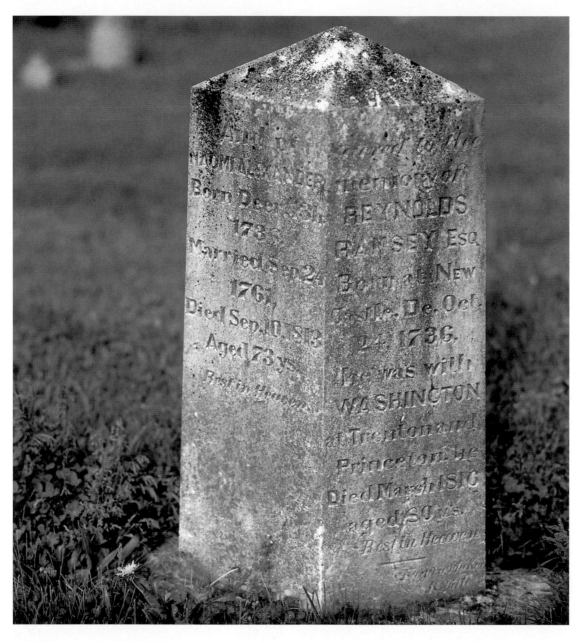

Patriarch of the influential Ramsey family of Knox County, Reynolds Ramsey did not live in Knox County until he was over seventy years old. Here on this mini-obelisk at Lebanon-In-the-Fork, his birthplace is inscribed as New Castle, Delaware. However, Ramsey's place of birth has been an enigma to family genealogists; Mr. Ramsey allegedly told stories recalling that his mother fell into the ocean and drowned before she got to America. Ramsey married Naomi Alexander; the two had five children and spent most of their lives in Pennsylvania, near Gettysburg. In his thirties, Ramsey enlisted as a private in the Revolutionary troops. According to family sources, he served under Washington at Valley Forge, Princeton, and Trenton. A miller, Ramsey was proud of telling stories about how he'd rather go broke than mill flour for the British troops.

He and his wife, Naomi, moved to Knox County in 1808, long after their sons, Francis and Samuel Ramsey, were established here. The elderly veteran was a popular character, fondly recalled as one of the last Knox Countians who wore a powdered wig and a cocked hat.

Naomi Ramsey's inscription includes a mathematical error oddly common in early graves, indicating that she was "73 ys" at death; her dates inscribed on the same stone indicate she was almost seventy-seven.

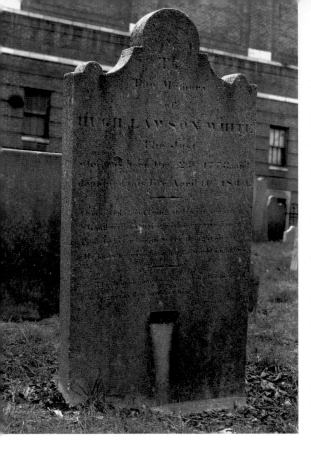

To the Memory of Hugh Lawson White
"The Just" who was born Octr 29th, 1773
and departed this life April 10th, 1840
"Composed in suffering and in joy sedate
Good without noise, without pretense great,
True to his word, in every thought sincere,
He knew no wish but
what the world might hear."
This humble tribute of devoted affection
and deep regret is deposited
by his bereaved wife.

Hugh Lawson White, son of Knoxville founder James White, was famous even as a young man. He was the Indian fighter who killed Chief King Fisher in 1793 during John Sevier's vengeful raids into Cherokee territory. White later founded Knoxville's first bank and became a regionally popular politician, a close Democratic ally of Andrew Jackson. When Jackson resigned his Senate seat, the state legislature picked White to replace him. There, though his Senate colleagues made fun of his emaciated appearance—they called the thinnest U.S. senator "the Skeleton"—White gained the esteem of his colleagues, and upon John Calhoun's resignation as vice president, White was elected president pro tempore of the Senate. For a few weeks in 1833, Hugh Lawson White was second in line for the U.S. presidency.

By 1834, White had begun to question the policies and personality of his mentor, Jackson; that year, a delegation of anti-Jackson Whigs, including Rep. Davy Crockett, nominated White to challenge Jackson's allies for the presidency. In this election without counterpart in U.S. history, the Whigs finally nominated three candidates to run against Jackson's hand-picked successor, Martin Van Buren: William Henry Harrison, Daniel Webster, and White.

Van Buren won anyway. White came in third, carrying only Georgia and Tennessee—in spite of Jackson's vigorous campaigning in his home state for Van Buren—but with more votes nationwide than Daniel Webster scored.

White stayed in the Senate, and was back in Knoxville for a Whig rally in the terrible summer of 1838, when he came down with the fever that killed hundreds here. The sixty-five-year-old senator survived the plague months, but he never fully recovered, growing weaker after his return to Washington. He resigned from the Senate and died soon after his return to Knoxville—during the presidential term he had campaigned for.

This stone at First Presbyterian, erected by his young second wife, was intended to be a temporary marker while White's allies arranged to build a much larger monument, which would be more fitting to commemorate one of Knoxville's most powerful politicians. But, according to Presbyterian minister James Park, "in the stirring scenes of the Presidential campaign of 1840, and the political excitement of the next few years, the project was lost sight of or abandoned."

The brick wall in the background is the rear of the Tennessee Theater.

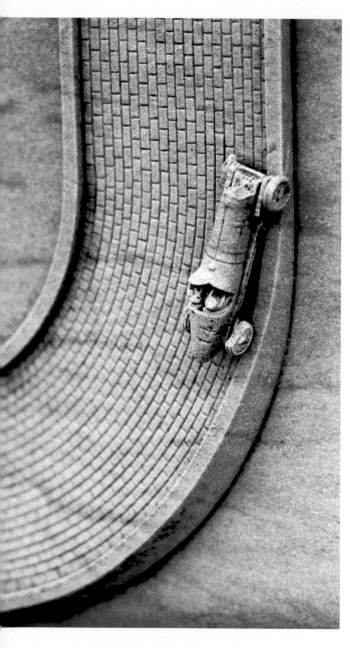

A. J. "Pete" Kreis grew up with the automobile. Heir of a prosperous German-speaking Swiss family which had pioneered Knoxville's marble industry, the young Kreis never had to work very hard, and even as a teenager in the era of Barney Oldfield, Kreis raced primitive automobiles on Knoxville's dirt tracks. He graduated from Central High, then went to the West Coast "to break into the game" of racing. Kreis never married, devoting most of his short adult life to racing automobiles. He encountered unusual success. In 1925, he placed eighth at the Indianapolis 500. In 1927, Kreis won the Italian Grand Prix.

But his passion was the Indianapolis 500. In 1930, Kreis's car, driven by a substitute driver when Kreis fell ill with the flu, won the big race. He placed second in 1931 and was in sixth place in 1933 when his car crashed. Surviving numerous wrecks and even one plane crash in the river near Island Home, Kreis promised his family he'd cut back on racing, concentrating only on the elusive Indy 500—and, perhaps, breaking the speed record of 272 mph at Daytona.

With his custom-built, eight-cylinder "Hartz-Miller Special," Kreis was a favorite to win the 1934 Indianapolis 500.

Early on the morning of Friday, May 25, 1934, Kreis was in Indianapolis riding with his mechanic on a trial run of the famous course.

After several low-speed laps, Kreis took the flag and accelerated to about 100 mph. He lost control in the first turn. His car rode up the retaining wall, straddled it for about 75 feet, then fell, smashing into a tree 15 feet below. Kreis died instantly; his mechanic died minutes later. They were the twenty-fourth and twenty-fifth racers ever killed at Indianapolis.

His family brought Kreis home to a huge funeral. Flower arrangements resembled the black-and-white flag; another arrangement depicted a broken steering wheel, 12 feet in diameter. Kreis was buried here three days before the race he died preparing for.

His family, strongly associated with Knoxville's marble industry, enlisted East Tennessee's best-known marble sculptor, Italian immigrant Albert Milani, to carve a unique gravestone for Kreis at Asbury Cemetery in south Knoxville. Milani had just finished carving the marble eagles that adorn the Post Office building on Main Street. On a huge twelve-foot-long chunk of marble, Milani carved this representation of the Indianapolis Speedway, accurate down to the brickwork of the famous "Brickyard." On this huge marble plinth, the tiny, remarkably detailed model racer is placed in the precise location where Kreis's car left the track. The checkered-flagman is to the left. Kreis's own portrait appears in bas-relief in the middle.

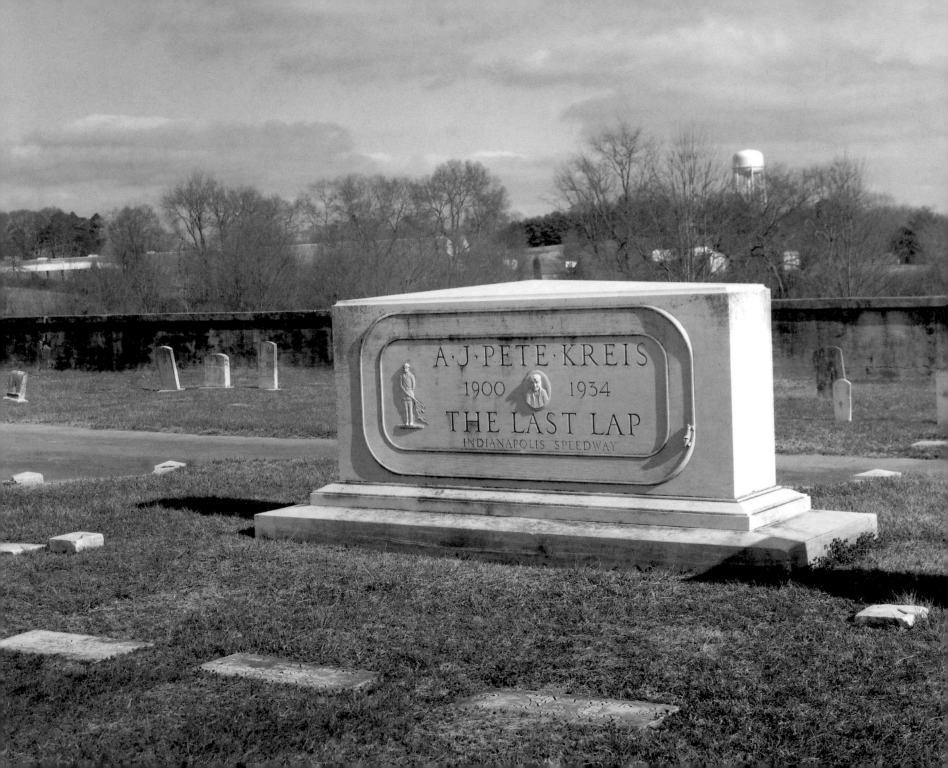

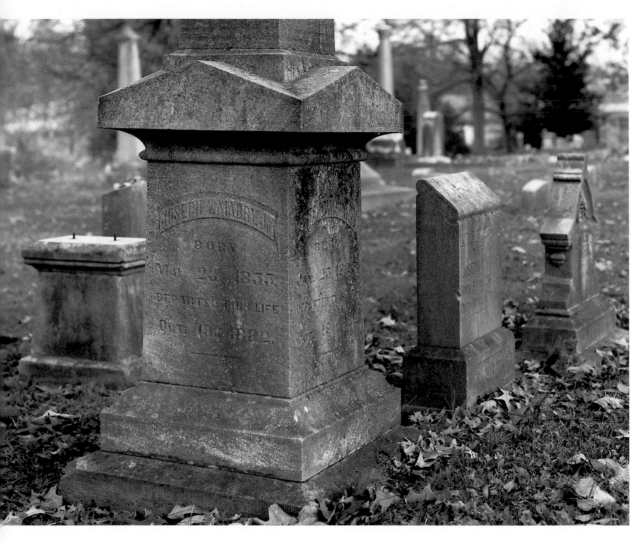

Joseph A. Mabry Sr. and his son, Joseph A. Mabry Jr., commemorated on these two sides of this obelisk in Old Gray, share the same death date: October 19, 1882. Thomas O'Conner's grave, on the opposite side of the same cemetery, is inscribed with the same date.

The three men were among Knoxville's professional elite in 1882; the elder Mabry and O'Conner were among Knoxville's very wealthiest citizens. All three died within moments of one another in one gunfight on Gay Street.

At forty-six, banker Thomas O'Conner, owner of the new Mechanics Bank and Trust, was reputedly the wealthiest man in Tennessee. He'd had a business dispute with Joseph Mabry, the philanthropist who long before had helped establish Market Square. A staunch Confederate sympathizer during the war, Mabry donated land near his own house for a Confederate cemetery.

O'Conner had been a Confederate officer during the war. Still, on the rainy Thursday morning of October 19, O'Conner stood outside his Gay Street bank with a loaded shotgun, waiting for Mabry, who had allegedly threatened him. Though a fifty-six-year-old father of seven who lived in a comfortable home and had a solid record of public service, Mabry was feared by many Knoxvillians. He had been involved in several gunfights in the past and was known to go armed.

When O'Conner saw Mabry on the crowded sidewalk opposite his bank, he shot him. Then, as Mabry's twenty-seven-year-old son, who was several paces behind his father, saw what had happened, he returned fire and killed the banker; but, as O'Conner fell, he shot the young lawyer. All three men died almost instantly; several bystanders and a horse were wounded.

All three were buried at Old Gray on the same day. Thomas Humes, an Episcopal priest and former president of the University of Tennessee, performed parts of all three ceremonies.

Local editors expressed the hope that the incident would be forgotten before it gave Knoxville a reputation for violence. However, within months, the well-known novelist Mark Twain published his most famous work of nonfiction, *Life on the Mississippi*. In chapter 40, "Castles and Culture," Mark Twain took some glee in reprinting, as an extended footnote, a lengthy wire-story account of the Mabry-O'Conner shootout as an example of the idea of Southern chivalry, "thoughtlessly omitted" from more romantic narratives.

Thomas O'Conner's wife, Fanny, survived him by over forty years, living quietly in Melrose, the extravagant home her husband had bought near the university campus.

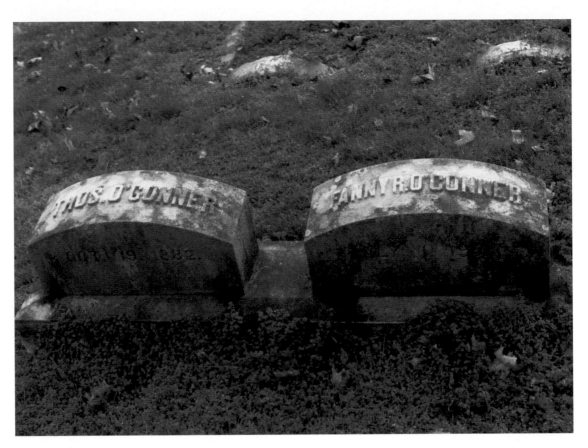

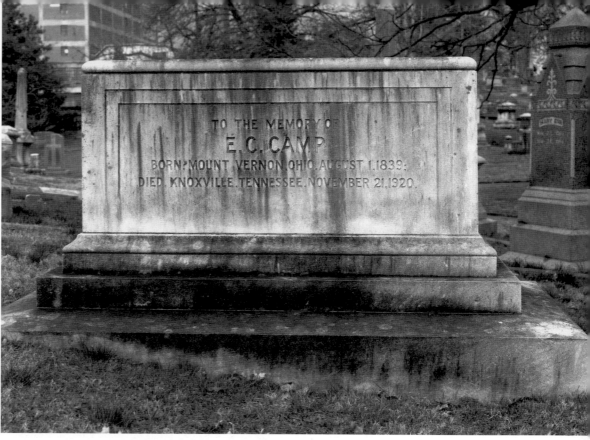

Appomattox didn't settle all the scores of the Civil War. For several years after the conflict was officially over, Knoxville witnessed war-related fights and murders. In 1868, former Confederate colonel Henry Ashby encountered an old enemy on Walnut Street. It was a former Union man, Maj. Eldad Cicero Camp, who had accused Ashby of mistreating Union prisoners during the war. The two armed men scuffled, and Camp shot Ashby dead.

Pleading self-defense, Camp was exonerated of the crime, and, after making a fortune in the coal and marble industries, he eventually became one of Knoxville's wealthiest and most prominent citizens and an important reform-era philanthropist. His 1890 mansion, Greystone, was on Broadway not far from Old Gray. (It later became the studios of WAVE TV.)

A few years after Ashby's burial, Governor Brownlow, one of the most ardent Unionist anywhere, was buried right across the lane from the Confederate colonel, an irony visitors have commented on for years.

Camp also was buried in Old Gray, but at a considerably greater distance away.

Calvin—or Caledonia, as he was sometimes called—Johnson lived a life too incredible to be imagined by Horatio Alger. Raised as a slave in downtown Knoxville, he became a driver for the Union army during the Civil War, traveling with Irish saloonkeeper Patrick Sullivan. Working as a gravedigger after the war, Johnson earned enough money to start his own grocery. Through hard work and shrewd investments, Johnson eventually owned a chain of saloons in Knoxville, real estate, a horse-racing track, and other businesses. He also became an important turn-of-the-century philanthropist, investing in a YMCA and a park for the black community.

His wealth has been conservatively estimated in the six figures—in early-twentieth-century dollars. He was reportedly the wealthiest black man in Tennessee. Johnson died in his large, handsome residence in downtown Knoxville in 1925, hardly two blocks from where, eighty years earlier, he had been born a slave. He's buried in his tenuously fenced family plot in the Oddfellows Cemetery in East Knoxville.

This marble stone with its mazelike design belongs to James Maynard Jr., grandson of erudite statesman Horace Maynard, a Reconstruction Republican congressman and minister to Turkey. James Maynard graduated from Princeton and spent part of his youth traveling the world, retracing his grandfather's footsteps, even enjoying Turkish coffee in Constantinople with some of his grandfather's old associates. He returned to Knoxville to work as an attorney and became a strong progressive voice in municipal politics. In the wee hours of New Year's Day, 1917, James Maynard died in his Fort Sanders home after a "brief illness." He was only thirty-six. Later residents of Maynard's White Avenue home—which would become known as "the Judge's House"— reported hearing voices and curious knocking sounds and believed the house to be haunted by young Maynard's ghost.

His elaborate tombstone is in Old Gray, not far from where his famous grandfather is buried. The Celtic cross shown here had become fashionable in the late nineteenth century, especially among families of Irish or Scottish heritage.

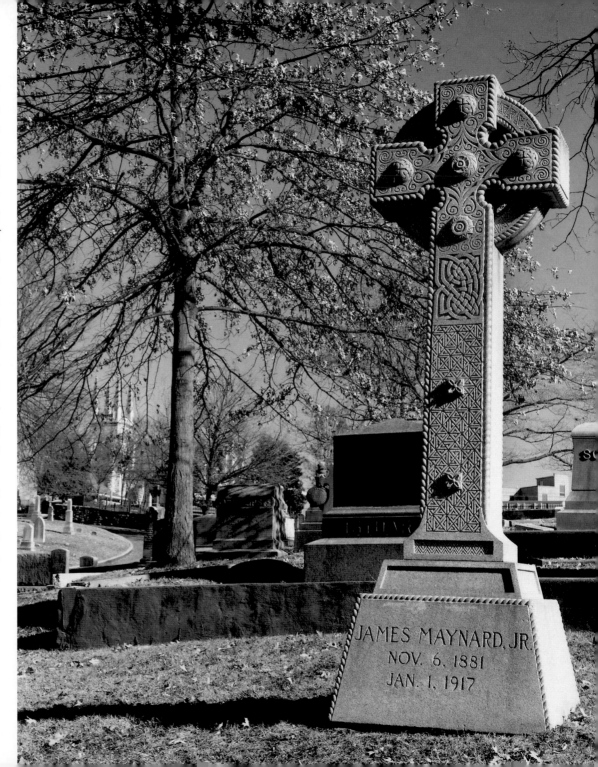

Edward Terry Sanford is Knoxville's only justice of the U.S. Supreme Court. The grandson of Swiss immigrants, Sanford was born in Knoxville and attended the University of Tennessee and Harvard. A prominent Knoxville lawyer, judge, and orator, Sanford served as a U.S. district attorney and federal judge before he was appointed to the nation's highest bench by President Harding and confirmed by Congress in 1923. Among his colleagues were Oliver Wendell Holmes, Charles Evans Hughes, and Chief Justice (and former president) William Howard Taft, with whom the conservative Sanford often allied himself.

Stricken suddenly in a Washington dentist's chair, Sanford died on March 8, 1930. Only five hours later, Justice Taft, who had recently retired, citing ill health, also died in Washington. The deaths of the two Supreme Court justices on the same day brought comparisons to the coincidence of the deaths of Jefferson and Adams in 1826.

Sanford's burial at Greenwood was attended by dozens of judges, including four of the eight surviving justices of the U.S. Supreme Court. One was the newly inaugurated Chief Justice Hughes. All left the brief burial service quickly in order to board the train for a speedy trip back to Washington in time for Justice Taft's funeral at Arlington.

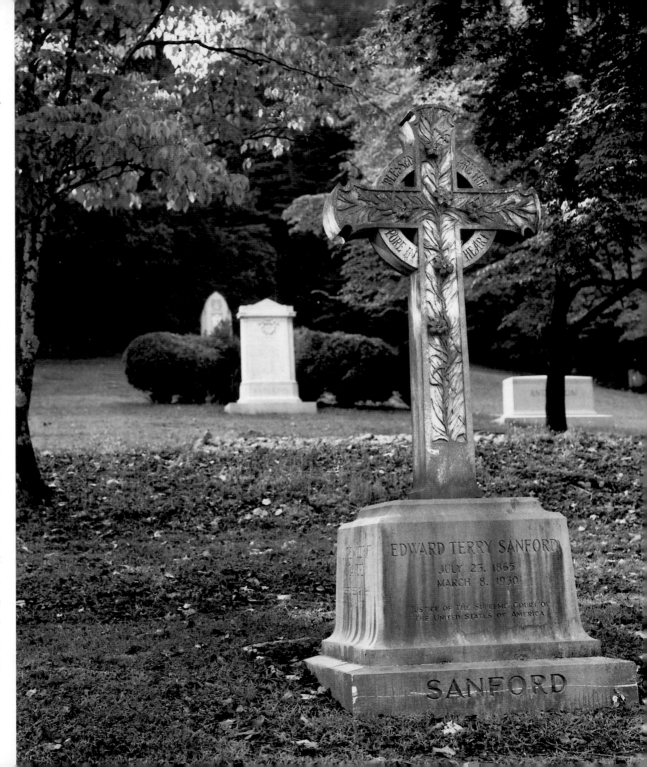

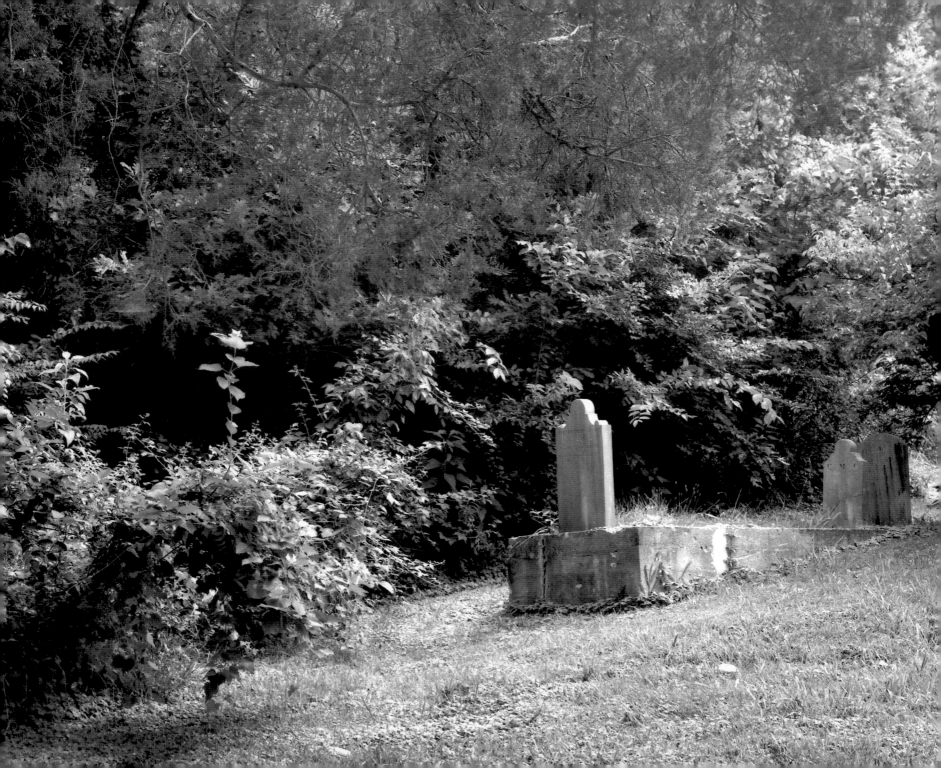

Knox County's oldest marked burial was carried out entirely by women. Elizabeth Carrick, the wife of Presbyterian minister and schoolteacher Samuel Carrick, helped her husband in his unlikely efforts to teach the classics to pioneers at their home on the Holston River, a few miles east of the territorial capital, Knoxville. In September 1793, Elizabeth Carrick came down with one of the fevers of the day and died at her home.

Her death, untimely in the best circumstances, came at the moment of the most dangerous crisis in Knoxville history. On the west side of town were massed some one thousand Indian warriors, a militant group led by hardline Chickamaugans Doublehead and John Watts, who were intent on destroying Knoxville, the white man's territorial capital. All thirty-eight white men in town, including the grieving young minister, were called to help in the city's defense. As Reverend Carrick bore arms alongside Capt. James White, he left the women of his community to bury his wife. With no men present to help, the women floated Elizabeth Carrick's body down the Holston in a canoe and buried her on this hillside, which became known as Lebanon-In-the-Fork, adjacent to a rustic church house where her husband had held services.

Meanwhile, Chickamaugan warriors destroyed Cavet's Station on Knoxville's west side, killing its inhabitants. Through a diversionary tactic, White, Carrick, and others of the band recalled as "the Invincible 38" succeeded in confusing the Chickamaugans and discouraging their assault on Knoxville itself without further bloodshed.

Elizabeth Carrick was almost certainly not the first person buried in Knox County. (Her gravestone itself was installed some years after her death by her grandson.) In 1875, historian J. G. M. Ramsey, who lived near here, claimed Lebanon-In-the-Fork to be "the oldest graveyard in the county," adding that this spot at the convergence of the Holston and French Broad Rivers had long served as a burial ground for itinerant trappers, traders, soldiers, and Indians even before Knoxville was settled. Ramsey said Elizabeth Carrick's was among the first Christian burials here. This churchyard soon surrounded the old Lebanon-In-the-Fork Presbyterian Church, which burned to the ground in 1981.

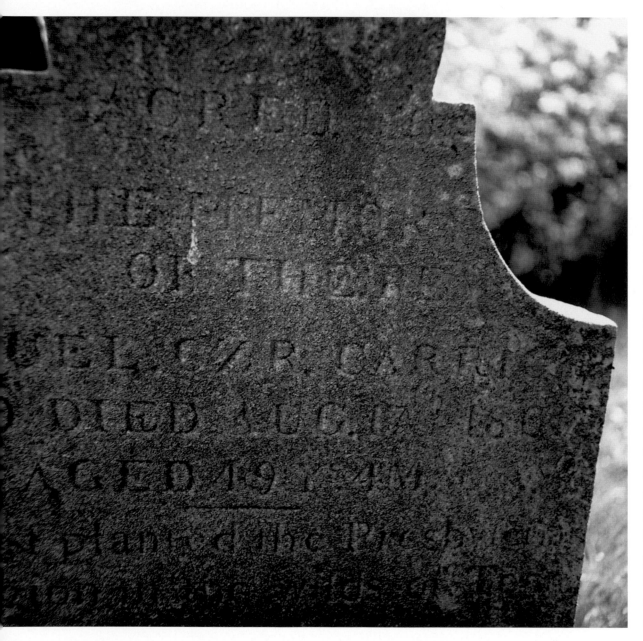

SACRED TO
THE MEMORY
OF THE REV.
SAMUEL CZR CARRICK
WHO DIED AUG 17TH 1809
AGED 49 YEARS 4 M.
[THERE FOLLOWS SOME POETRY
WHICH IS NO LONGER LEGIBLE.]

Born in Pennsylvania, Samuel Carrick was the young minister who brought the Presbyterian Church to Knox County and founded the school of the classics that slowly evolved into the University of Tennessee. Contemporaries remembered Carrick as "very grave and dignified . . . generally taciturn, if not reticent," as well as "ruddy . . . handsome" and "inclined to corpulency or rather plethoric." Samuel Carrick outlived his first wife by sixteen years, but still died relatively young, at age forty-nine, reportedly after staying up all night to finish a sermon. The school he had founded, now known as East Tennessee College, was in serious financial trouble. Buried in the old graveyard (which only later became known as the First Presbyterian churchyard), his grave happened to be directly across State Street from his one-house college—which remained closed for eleven years after Carrick's death. Though Carrick is credited with found-

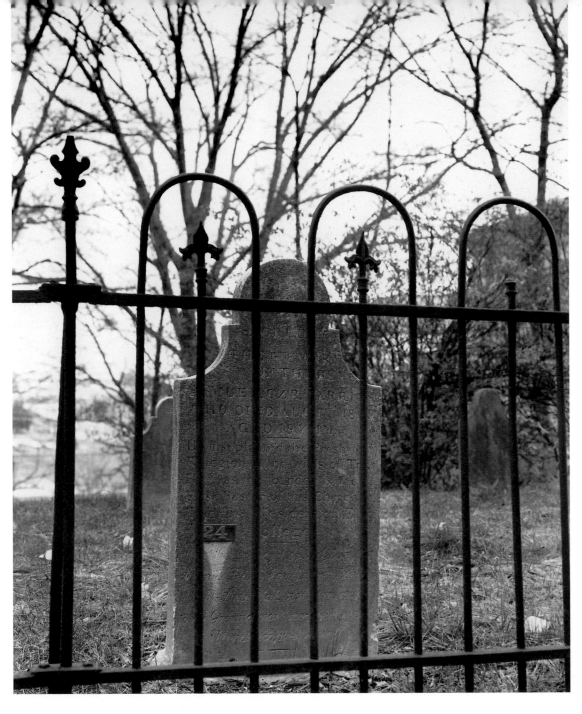

ing the Presbyterian Church in Knoxville, he didn't live to witness construction of any sanctuary in Knoxville. The first permanent church building in Knoxville went up seven years after its founder's death.

One enduring mystery is the engraved abbreviation "czr" on the original inscription, which is placed as if it's a middle name. It was a puzzle considered in 1894 during the university's centennial celebrations in a speech by attorney Edward Terry Sanford, future justice of the U.S. Supreme Court (see p. 35). Some historians have found evidence suggesting that Carrick's middle name was "Czar" or "Czare," but why a baby born into a Virginia Presbyterian family should be given a name suggestive of the ruler of Russia—in a period when few American babies were given middle names at all—remains unexplained.

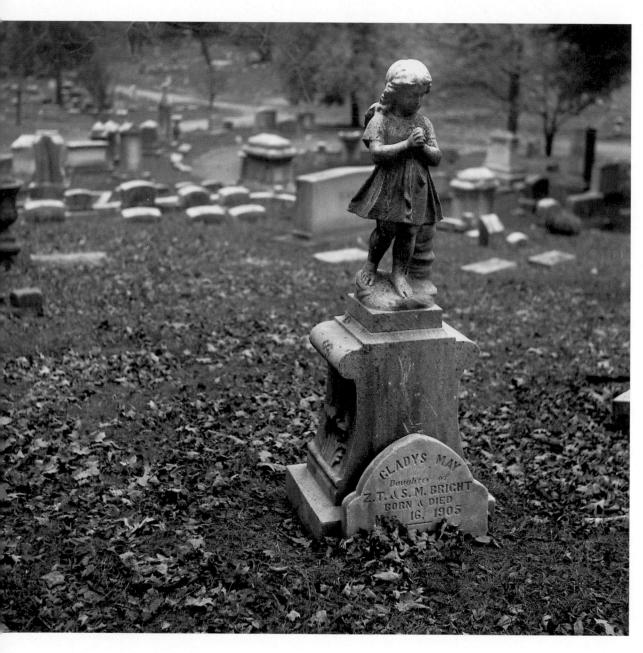

GLADYS MAY
Daughter of
Z. T. & S. M. BRIGHT
BORN & DIED
MAR 16, 1905

Though wealthy families sometimes remembered older children with a statue meant to resemble the deceased, babies and children under the age of five were typically commemorated with childlike angels, like this one in Old Gray. Gladys May Bright, the daughter of carpenter Z. T. Bright, apparently died the day she was born. Later, in the early twentieth century, some found it comforting to bury children together. One field in New Gray Cemetery (opposite) is devoted to hundreds of children's graves dated between 1910 and 1940. The stones in this field are all appropriately small, many in the shape of a lamb or a heart.

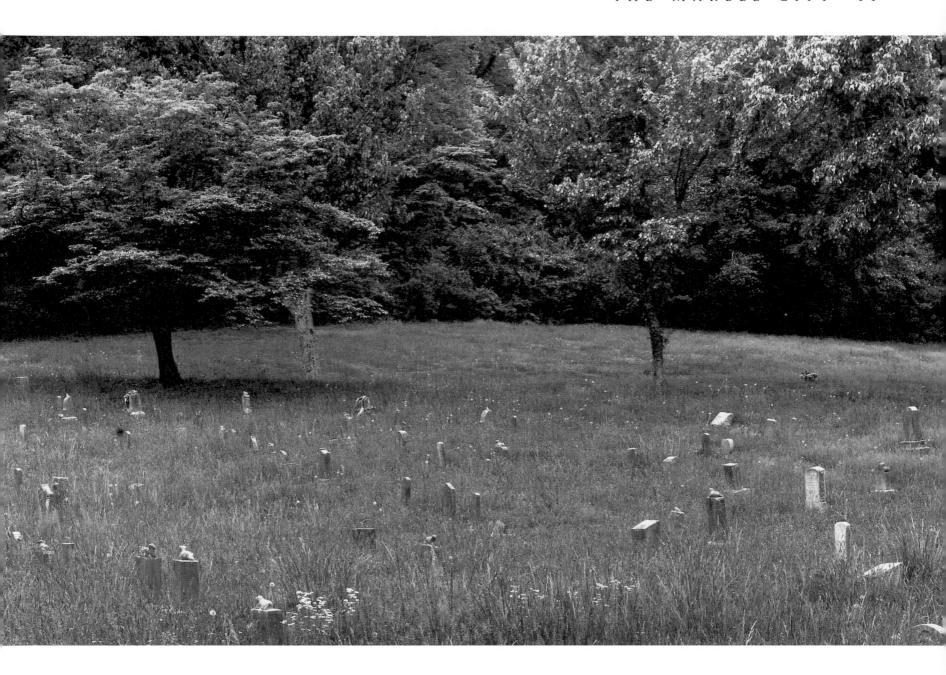

Six-year-old Robert J. McKinney died at his
wealthy father's Main Street home in 1888 after
a two-month illness described as "tubercular
meningitis." His parents, Sam and Annie B.
McKinney, commissioned this statue based on a
earlier portrait by artist Lloyd Branson. The
statue originally held a riding crop, which has
since been broken.

This marker is older than Greenwood Cem-
etery, where it stands; the burial was originally
at Old Gray. Family members moved their whole
plot here in the twentieth century.

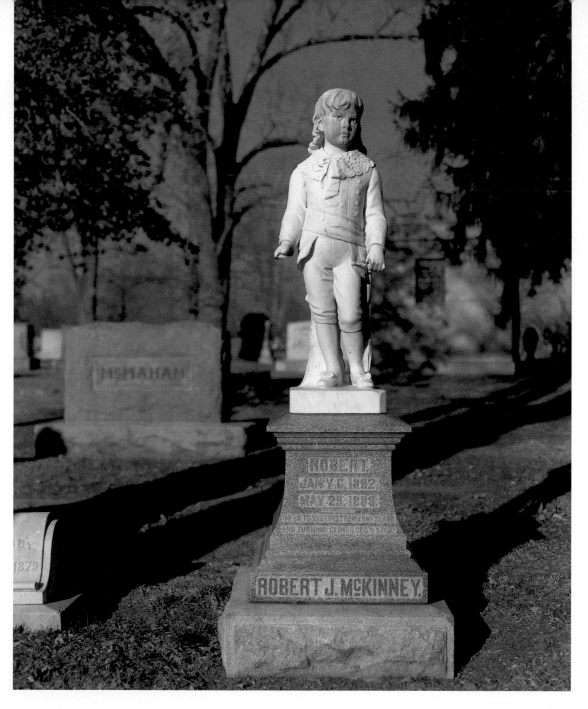

This startlingly lifelike statue at Old Gray recalls Lillien Gaines, a Knoxville-born girl who died in April 1876, at the age of seven. Her parents might have seemed a mismatched pair: her father was a Knoxville native who became a Confederate officer; her mother was a beauty from Ohio. In the last days of the war, Gaines lost his arm to a wound. He approached his Northern fiancée, offering to release her from their pact due to his "mutilation and poverty." She married him anyway, and they had three children. The youngest was Lillien.

In 1876, Mr. Gaines was elected Tennessee state comptroller and moved his family to Nashville. Soon after their arrival Lillien became ill and, several weeks later, unexpectedly died. Her parents buried her in the city she knew best; though they spent much of their lives away, both of Lillien's parents were eventually buried nearby.

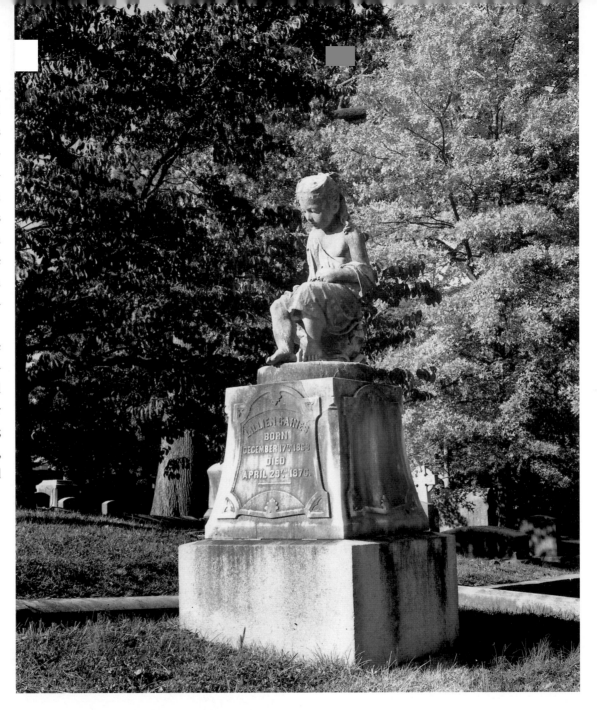

Richard Keyhill organized the original Island Home Baptist Church just before the Civil War. He died in 1879, and is buried in the churchyard. Located directly adjacent to a church, the churchyard itself is of a plan which was by then already frowned upon across the river in Knoxville proper, and the primitive simplicity of the lettering on Keyhill's own grave seems more reminiscent of eighteenth-century graves than those of the extravagant Victorian era; it's obviously very different from the flamboyant contemporary tombstones at Old Gray, hardly three miles away.

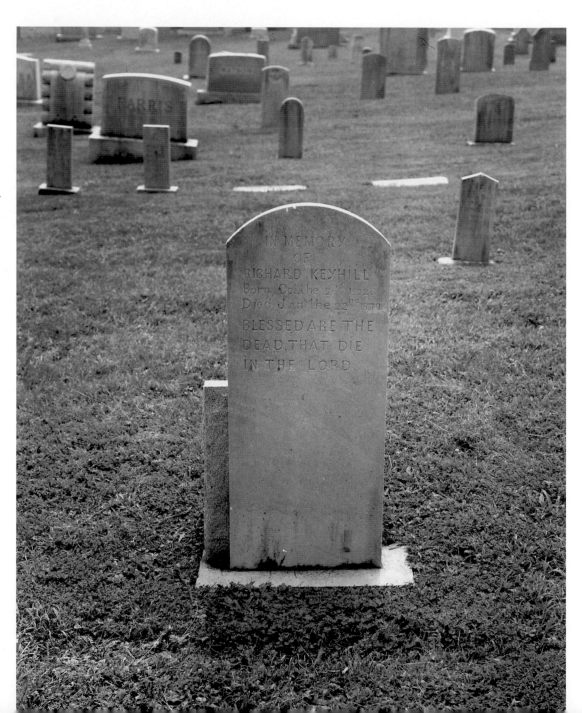

This defaced statue of a Civil War soldier wears a belt buckle still clearly marked "CS" (for Confederate States) and stands at attention in a northern corner of Old Gray. According to the legend, he has his back turned to the Union graves of the National Cemetery by request of one of the two soldiers interred here. In fact, this statue could represent either of these Confederate brothers.

William A. Horne was only sixteen when he enlisted. With the 43rd Georgia Regiment, he fought in the battles of Atlanta and Franklin; he was under the command of Gen. Joseph Johnston at the time of the surrender.

After the war, William Horne returned home to serve twice as a Knoxville alderman. In 1891, the younger Horne died at his Fifth Avenue home of typhoid, which, according to the *Knoxville Journal,* "baffled the skill of the best physicians."

His older brother John would be known as General Horne late in life—but it was an honorary designation bestowed upon him, decades after Appomattox, by the Felix Zollicoffer Camp of the United Confederate Veterans. During the war, John Horne had actually been an artillery sergeant who was captured by Federals at Cumberland Gap in 1863 and spent most of the rest of the war in a Union prison camp. He returned to Knoxville, and until his death in 1906 he made a career as a merchant on Market Square.

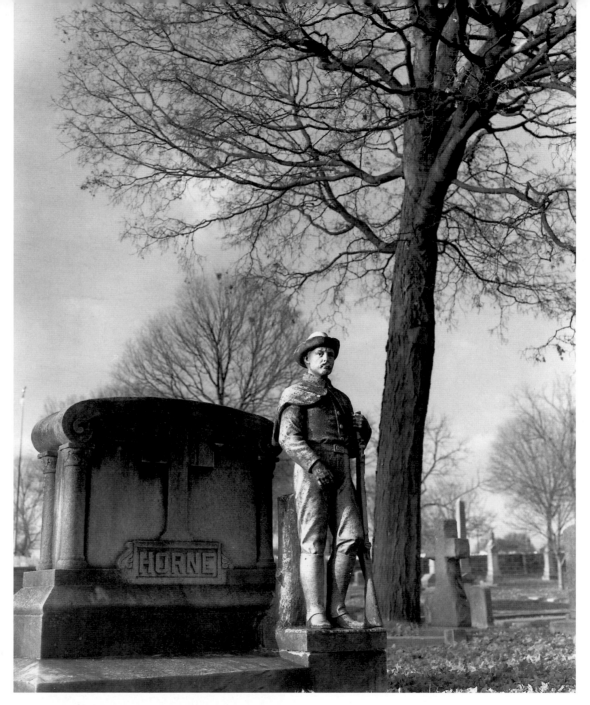

These two lonely graves overlook one of Knoxville's most crowded burial fields: Bethel Cemetery, where some sixteen hundred Confederate soldiers (and perhaps fifty unknown Union men) are buried. Most died in the Knoxville area during the Confederate occupation (1861–63) and are buried without individual markers. The field was donated for the purpose by Joseph Mabry, the strong Confederate sympathizer later killed in a gunfight and is immediately adjacent to the Catholic Calvary Cemetery as well as Potter's Field, which were both established soon after the war.

A forty-eight-foot shaft in the background, topped with a flamboyant statue of a Confederate soldier defiantly facing northward, honors the Southern dead en masse. It was dedicated in an elaborate ceremony of Confederate veterans in 1892.

The two graves in the foreground represent a minority of non-soldiers buried here; they belong to two women of the Lusby family, who died in the 1870s. Susan Lusby Herman, whose marker is on the left, died at nineteen, in her first year of marriage.

Originally established by Gen. Ambrose Burnside during the Union occupation of Knoxville in 1863, Knoxville's National Cemetery is among the nation's oldest officially sanctioned military burial grounds.

By 1892, the graying rebels of Knoxville had distinguished their own graveyard with a tall monument with an artistic statue of a dashing Confederate soldier on top. For years, it stood as an embarrassment to Union veterans, who insisted they needed a taller monument. A committee led by editor William Rule solicited donations from Union veterans and their families, and, in 1900, the committee erected an impressive new monument: a castlelike stone structure with an inner staircase and stained-glass windows, surmounted with a warlike bronze eagle with spread wings. It was the largest Union monument in the South. But during an evening thunderstorm in August 1904, a lightning bolt struck the eagle, shattering it and most of the structure it perched upon. The strike shook the whole city and was heard for miles around.

The original building committee went back to work, this time with federal funding. They rebuilt the marble base, and installed a marble statue of a Union soldier that stands slightly taller than the soldier atop the Confederate monument—and which has fared the lightning storms of the Tennessee Valley better than the original eagle did.

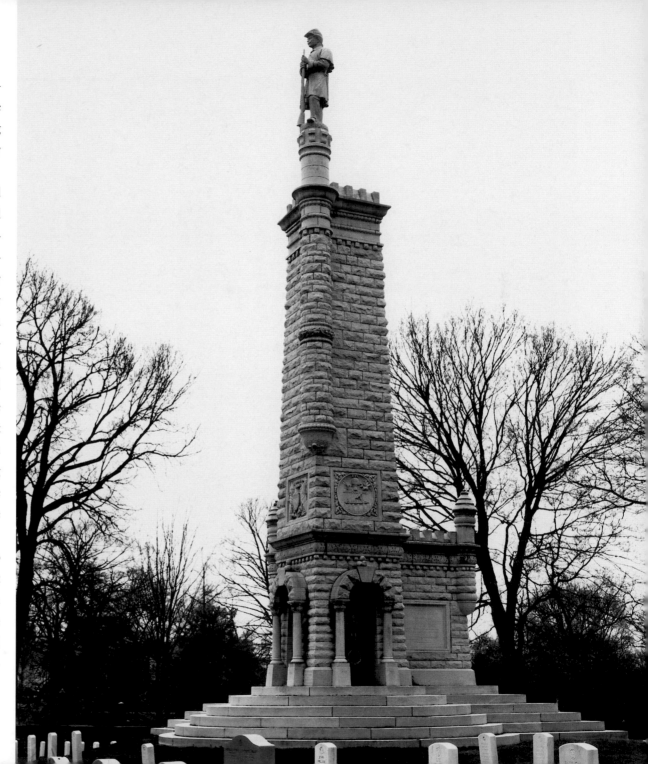

SACRED
TO THE
MEMORY OF
ABNER BAKER
BORN AUG. 15, 1843
DIED SEPT. 4, 1865
"A MARTYR FOR MANLINESS AND
PERSONAL RIGHTS HIS DEATH WAS
AN HONOR TO HIMSELF BUT AN
EVERLASTING DISGRACE TO HIS
ENEMIES.
COWARDS DIE MANY TIMES
THE BRAVE BUT ONCE."

THE FRIENDS OF ABNER BAKER
ERECT THIS MONUMENT
IN COMMEMORATION OF HIS VIRTUES,
AND IN TESTIMONY
OF HIS GOODNESS AND MANLY WORTH.
FRESH BE HIS MEMORY.

The overcrowded graveyard at First Presbyterian Church was closed to new burials by city ordinance in 1857, after Old Gray had opened. Few exceptions were made to the closure, but one of them, dating from 1865, resulted in the tallest monument in the cemetery. It belongs to Abner Baker, the diminutive twenty-two-year-old Confederate veteran lynched on Hill Avenue for

murdering another young man in a fight. Baker's motive for killing was unknown, but many assumed he was seeking vengeance for the murder of his father, a prominent surgeon who was killed in his own home along the Kingston Road in West Knox County during the siege of Knoxville, apparently by Union troops. "A martyr for manliness and personal rights," his stone reads, "his death is an honor to himself and an everlasting disgrace to his enemies."

Abner Baker's monument, an obelisk with its top broken off, is nevertheless the tallest monument in this old graveyard. It may have been intact at one time, but the break was likely intentional: in some cases a broken obelisk monument symbolized the premature death of a prominent youth and potential unrealized.

At the time of Baker's death, this churchyard was in a state of extreme disrepair, recently used as a playground for freed slave children and even as a trash dump. Ghost stories concerning Abner Baker's hanging were circulating by 1870, when Adolph Ochs—the young, impressionable future publisher of the *New York Times*—was loath to walk past this graveyard alone at midnight.

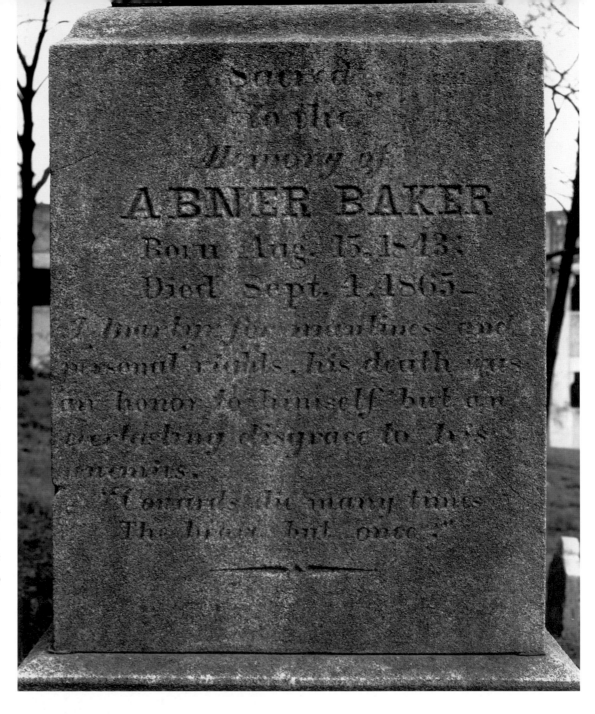

William Caswell joined the Confederate army as a teenager. After the war, still only nineteen, he joined the predominately Confederate Knoxville baseball team, the "Holstons," and played in what was probably the first baseball game in the region. After a successful career as a businessman and state public servant, Caswell worked on developing north Knoxville, where he lived, donating a sixty-acre tract that became known as Caswell Park. For most of the twentieth century, the park would be the center of Knoxville professional baseball, black and white alike. Bill Meyer Stadium was later built on the site.

It's symbolic of Knoxville's reconciliation that this Confederate veteran—the son of a murdered Confederate general, at that, and married to one of Knoxville's strongest pro-Confederate families—befriended William Rule, the former Union captain, and conspicuous promoter of Union memorials. The elderly Captain Rule was, in fact, a pallbearer at Caswell's funeral at Greenwood Cemetery.

Caswell died in 1926, only six months after his wife, Elizabeth Boyd. A *Knoxville News-Sentinel* editorial in 1926 reported that with Caswell's death, "Knoxville loses one of its few remaining pioneer citizens who knew her when she was but a straggling village . . . to witness her development into the skyscraper metropolis of East Tennessee."

Old Gray's name sometimes leads newcomers to believe the cemetery has something to do with the Confederate cause, but it was named "Gray" years before the Civil War. It is, in fact, the final resting place of many Union soldiers, including several officers; and this obelisk, one of Old Gray's largest markers, belongs to Tennessee's single most fearlessly outspoken Unionist, "Parson" William G. Brownlow, who became the Reconstruction governor of Tennessee.

Originally from Virginia, the self-taught Methodist minister was in his forties when he came to Knoxville. He brought with him a feverishly partisan newspaper he had founded in Jonesborough, the *Whig,* a weekly so marked by its often outrageous insults to many religious, ethnic, and political groups that it developed a nationwide following for its humor content alone. Imprisoned by Confederates early in the war, Brownlow escaped to the North, where he became a popular wartime lecturer. As the war ended, Brownlow was appointed governor of Tennessee to oversee Reconstruction. His zealous and often vindictive enthusiasm for the role gained him many enemies, among them the Ku Klux Klan, which repeatedly attempted to assassinate him and did murder some of Brownlow's agents. In 1869, the Reconstruction legislature elected him to the U.S. Senate. Despite more than fifteen years of threats to his life, Brownlow died quietly in his East Cumberland Avenue home at the age of seventy-two.

Hated for decades after his death, Brownlow provoked his enemies so much that his portrait had to be removed from the state capitol in Nashville because it was too frequently the target of spat tobacco.

Young Adolph Ochs, the Chattanooga publisher who had served his apprenticeship on a Brownlow paper, wrote an unusual eulogy for this unusual man. "Brownlow was a harsh man; a reliable hater; not particular to be politically consistent; eager to carry any point he set his head or heart on; endowed with a violent temper and a vindictive nature. . . . We confess no admiration, personal or other, for the dead governor and senator. [But] a more hospitable and mild-mannered gentleman at his home was never met by his peers; nor did a public man in Tennessee die with a cleaner record, for personal and official honor."

Brownlow did indeed have a noble side. One of his finer moments is a connection to Old Gray that predates his burial here. During Knoxville's cholera epidemic of 1854, he helped an Irish sexton, Neddy Lavin, dig graves for victims of the disease after most of Knoxville's populace had fled the city.

Much later, Brownlow biographer Merton Coulter concluded, "He made himself a monster to many of his contemporaries, and an enigma to future generations." His obelisk, shown at the left, is one of the largest monuments at Old Gray.

CHAVANNES

ALBERT CHAVANNES,
Feb. 23, 1836 – May 3, 1903.

CECILE CHAVANNES,
July 10, 1839 – July 28, 1909.

Born in Switzerland, Albert Chavannes was twelve years old when his family moved to Knoxville in 1848 to become part of the burgeoning Swiss community here. He married seventeen-year-old Cecile Bolli, another Swiss immigrant in Knoxville; daughter of a widely traveled Swiss consul, she had been born in Brazil. Albert Chavannes was involved in various business ventures when, in his forties, he became preoccupied with Darwinism, electromagnetism, spiritualism, and many of the other sciences, pseudosciences, and social theories of his day. He began writing novels and tracts to explore his ideas. His magazine, the *Sociologist,* commenced publication in 1883 and is sometimes described as America's first sociological journal. A political liberal who sometimes addressed conventions of the Populist Party, he advocated cooperative living and free love and eventually proposed a modern replacement for religion, a discipline he called Mental Science. He published most of his work himself, on his printing press at his home on East Fourth Avenue. However, one of his novels, *Socioland,* was published nationally by a New York firm. A futuristic vision of an ideal society in Africa, the novel was set in 1950—then the distant future.

Family members claimed that on his deathbed, Chavannes renounced his theories in preference for the Christianity he was raised with. In any case, he left a will leaving the community a large park, but with a typically eccentric addendum: "I leave my heirs the option to disregard it. . . . I do not believe in the dead controlling the actions of the living."

Albert and Cecile Chavannes are buried among many other Swiss immigrants at the Spring Place Presbyterian churchyard in northeast Knoxville.

Every city has one; this was once Knoxville's Potter's Field. This unusual stone monument, inscribed with verse, was installed in 1937, after the mass graveyard was closed to new burials. Though relatively small, the often overgrown graveyard in east Knoxville contains between three hundred and seven thousand burials, depending on whose estimate is most credible. Most of the graves are unmarked, and there are apparently no extant records at all. Even the date it was closed is open to debate, most suggesting it was used for a total of perhaps sixty years, and the last burial here was in the 1920s or 1930s.

What the people buried here had in common was that they lived in Knoxville when they died, and that they were poor, homeless, and in many cases unknown to anyone. It has always been popularly known as Potter's Field, as were similar graveyards in New York and other cities. The east Knoxville cemetery was once given the brighter euphemism Belleview, but even in newspaper stories describing the fate of homeless people found in alleys downtown, it was called Potter's Field.

The term comes from Matthew 27. When Judas Iscariot, remorseful for betraying Jesus, returned the thirty pieces of silver he had been paid, the chief priests "took counsel and bought with them the potter's field, to bury strangers in."

The passage inscribed on the column quotes "Elegy Written in a Country Churchyard" by Thomas Gray, the eighteenth-century English poet for whom two other cemeteries in Knoxville are named. The lines read, in part:

PERHAPS IN THIS NEGLECTED SPOT IS LAID
SOME HEART ONCE PREGNANT
WITH CELESTIAL FIRE;
HANDS THAT THE ROD OF EMPIRE
MIGHT HAVE SWAYED,
OR WAKED TO ECSTASY THE LIVING LYRE.
BUT KNOWLEDGE TO THEIR EYES HER AMPLE PAGE
RICH WITH THE SPOILS OF TIME
DID NE'ER UNROLL
CHILL PENURY REPRESSED THEIR NOBLE RAGE,
AND FROZE THE GENIAL CURRENT OF THE SOUL.

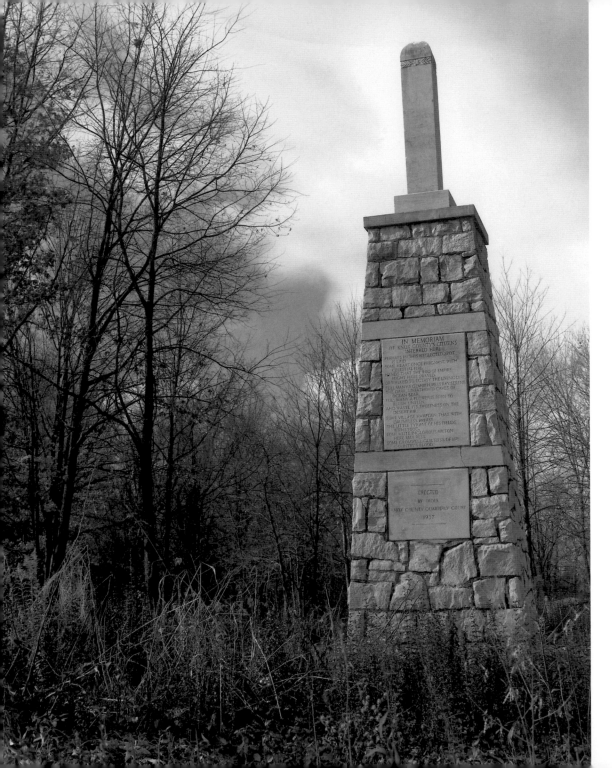

BIBLIOGRAPHY

Agee, James. *A Death in the Family.* New York: McDowell, Oblensky, 1957.

Brown, John Gary. *Soul in the Stone: Cemetery Art from America's Heartland.* Lawrence: Univ. Press of Kansas, 1994.

Clemens, Samuel. *Life on the Mississippi.* Boston: J. R. Osgood, 1883.

Coulter, E. Merton, with an Introduction by James W. Patton. *William G. Brownlow: Fighting Parson of the Southern Highlands.* Knoxville: Univ. of Tennessee Press, 1971.

Curl, James Stevens. *A Celebration of Death: An Introduction to Some of the Buildings, Monuments, and Settings of Funerary Architecture in the Western European Tradition.* New York: Charles Scribner's Sons, 1980.

Farrell, James J. *Inventing the American Way of Death, 1830–1920.* Philadelphia: Temple Univ. Press, 1980.

Jackson, Kenneth T., and Camilo José Vergara. *Silent Cities: The Evolution of the American Cemetery.* New York: Princeton Architectural Press, 1989.

Johnson, Gerald. *An Honorable Titan: A Biographical Study of Adolph S. Ochs.* New York: Harper and Brothers, 1946.

MacCloskey, Monro. *Hallowed Ground: Our National Cemeteries.* New York: Richard Rosen Press, 1968.

Ramsey, J. G. M. *History of Lebanon Presbyterian Church, 1791.* Reprint, Knoxville: Hubert Hodge Printing, 1973.

Sloane, David Charles. *The Last Great Necessity: Cemeteries in American History.* Baltimore and London: Johns Hopkins Univ. Press, 1991.

Taylor, Peter. *In the Tennessee Country.* New York: Alfred A. Knopf, 1994.

Williams, Tennessee. *Collected Stories.* With an Introduction by Gore Vidal. New York: New Directions, 1985.

The Marble City was designed and typeset on a Macintosh computer system using PageMaker software. The text is set in Granjon, and the titles in Aurea Titling and Aurea Inline. This book was designed and composed by Todd Duren, and manufactured by Friesens. The recycled paper used in this book is designed for an effective life of at least three hundred years.